NO EXPERIENCE REQUIRED!

CoLOReD and WaTeRCOLoR PeNCiL

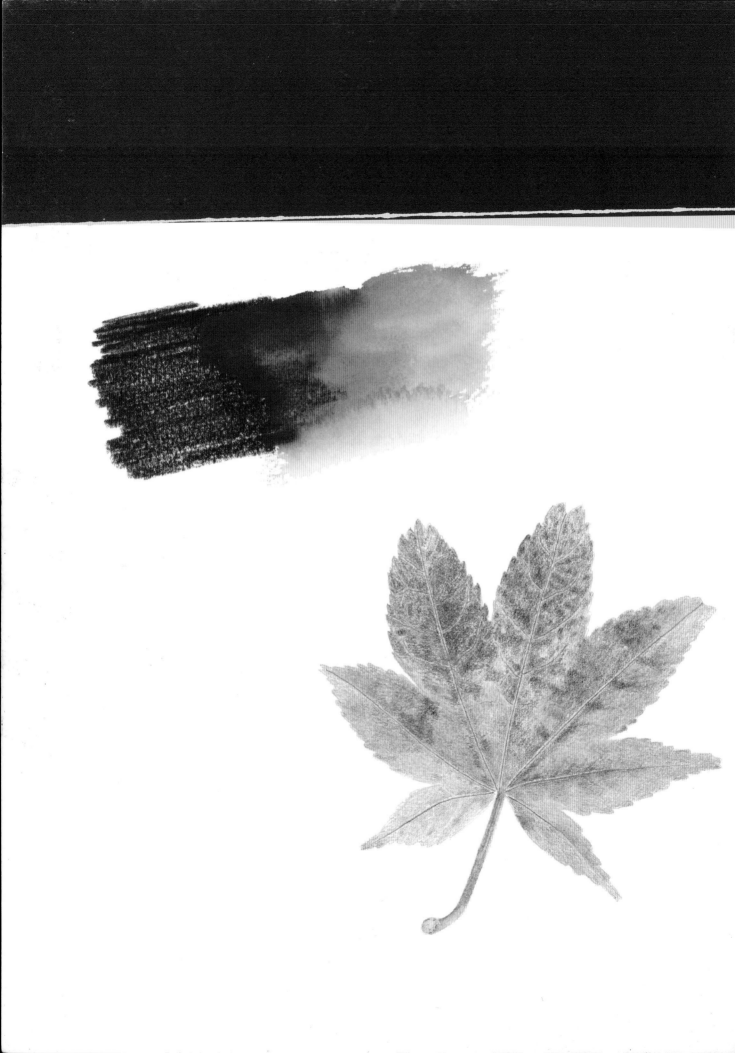

NO EXPERIENCE REQUIRED!

CoLOReD and WaTeRCOLoR PeNCiL

Gary Greene

NORTH LIGHT BOOKS
CINCINNATI, OHIO
www.artistsnetwork.com

Other fine North Light Books are available from your local bookstore, art supply store or direct from the publisher.

09 08 07 06 05 5 4 3 2 1

DISTRIBUTED IN CANADA BY FRASER DIRECT
100 Armstrong Avenue
Georgetown, ON, Canada L7G 5S4
Tel: (905) 877-4411

DISTRIBUTED IN THE U.K. AND EUROPE BY DAVID & CHARLES
Brunel House, Newton Abbot, Devon, TQ12 4PU, England
Tel: (+44) 1626 323200, Fax: (+44) 1626 323319
Email: mail@davidandcharles.co.uk

DISTRIBUTED IN AUSTRALIA BY CAPRICORN LINK
P.O. Box 704, S. Windsor NSW, 2756 Australia
Tel: (02) 4577-3555

Library of Congress Cataloging in Publication Data
Greene, Gary, 1942-
 No experience required! Colored and watercolor pencil / Gary Greene.
 p. cm
 Includes index.
 ISBN 1-58180-626-4 (pbk. : alk. paper)
 1. Colored pencil drawing—Technique. 2. Watercolor painting--Technique.
3. Water-soluble colored pencils. I. Title: Colored and watercolor pencil. II.
Title.

NC892. G747 2005
741.2'4—dc22 2004030583

Edited by Mona Michael
Art direction by Wendy Dunning
Interior design and production by Barb Matulionis
Production coordinated by Mark Griffin

About the Author

Gary Greene's career as a professional artist dates back to 1967. His experience includes working as an art director, graphic designer, technical illustrator, and professional photographer.

Gary is the author of *Creating Textures in Colored Pencil, Creating Radiant Flowers in Colored Pencil, Painting With Water-Soluble Colored Pencils*, and several Artist's Photo Reference books, all published by North Light Books. His colored pencil paintings and articles have appeared in (among others): *International Artist, The Artist's Magazine, American Artist, Creative Colored Pencil* (Rockport), *The Complete Colored Pencil Book* (North Light), and *The Encyclopedia of Colored Pencil Techniques* (Quarto). He has also produced five art instruction videos entitled: *Colored Pencil Video Workshop, Water-Soluble Colored Pencil Video Workshop, Textures in Colored Pencil Video Workshop, Painting Flowers with Colored Pencil Video Workshop* and *Artist's Guide to Reference Photography*.

Gary's paintings have won national and international awards including the Colyer-Weston Art League National Art Merit Competition, Artist's Magazine National Art Competitions, and two Colored Pencil Society of America (CPSA) Awards of Excellence. His work has been purchased and showcased by corporations such as: Lyra Bleistift-Fabrik (Germany), Paccar Inc, Parsons Brinckerhoff, Gango Gallery in Portland, Oregon, Blue Heron Gallery in Vashon, Washington, and Boston Art, Inc. in Boston, Massachusetts. Gary has conducted workshops, demonstrations and lectures nationally and internationally since 1985. He is a Ten Year Signature Member of the Colored Pencil Society of America (CPSA), and served on its founding Board of Directors for six years.

METRIC CONVERSION CHART

To convert	to	multiply by
Inches	Centimeters	2.54
Centimeters	Inches	0.4
Feet	Centimeters	30.5
Centimeters	Feet	0.03
Yards	Meters	0.9
Meters	Yards	1.1
Sq. Inches	Sq. Centimeters	6.45
Sq. Centimeters	Sq. Inches	0.16
Sq. Feet	Sq. Meters	0.09
Sq. Meters	Sq. Feet	10.8
Sq. Yards	Sq. Meters	0.8
Sq. Meters	Sq. Yards	1.2

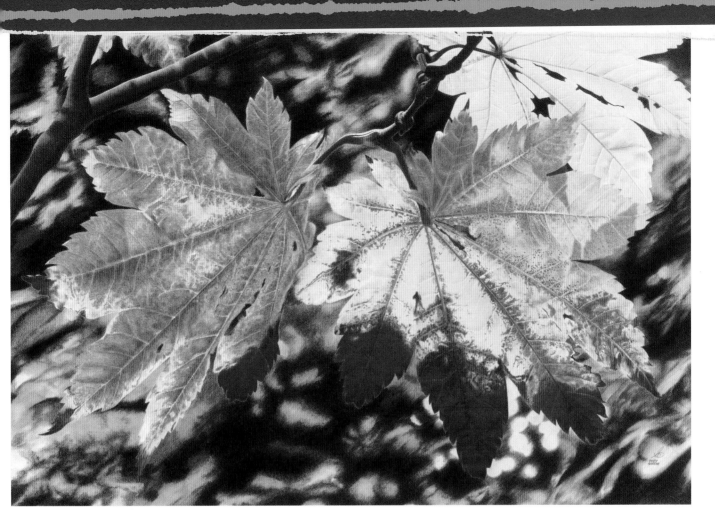

Dedication

This book is dedicated to all of the art teachers who insist,
"Work loose!" This is what happens when you don't listen
to them.

Acknowledgments

Thanks to my only wife Patti, for her encouragement,
patience and for affixing all the labels.

Table of Contents

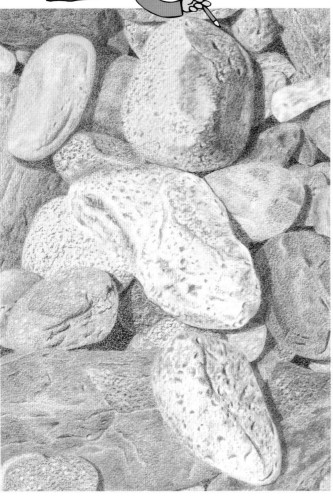

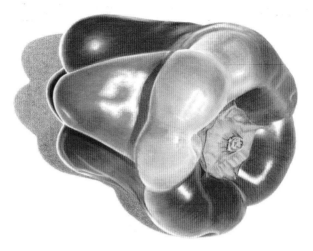

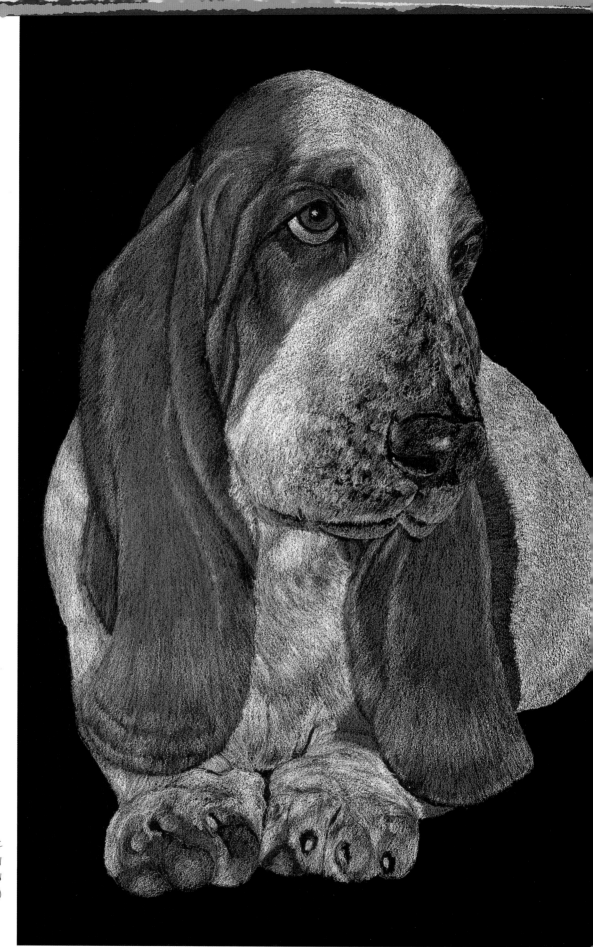

GRRTRUDE
Colored pencil
on museum board
8½" x 11" (22cm x 28cm)

Introduction

It must be love because the affair has lasted more than twenty years! That love is my passion for colored pencil. I attempted my first colored pencil painting back in 1983. At that time, colored pencil was not the mainstream medium it has become. Colored pencil art has gained acceptance and appreciation from artists and art lovers alike, thanks to the efforts of the Colored Pencil Society of America (CPSA), many talented colored pencil artists and the many fine books and articles that have been published.

Using this book, you'll learn some of the many ways to create exciting artwork with colored pencil. We will explore what you need and how to use it through twenty-four step-by-step demonstrations so, ladies and gentlemen, sharpen your pencils!

Gary Greene
Woodinville, Washington
September 2004

Getting Started

Before you begin any new art form, there are invariably supplies to gather. This chapter will introduce you to the most important supply—colored pencils—and how they work, as well as what tools and materials you'll need to make the most of your pencils. You'll also find color charts of all the colors used in the demonstrations for easy identification, and a complete shopping list of tools and materials.

SHOPPING LIST

PAPER
3-ply bristol vellum • 300-lb. (640gsm) cold-pressed watercolor • 300-lb. (640gsm) rough watercolor • Black 4-ply museum board • Canson Mi-Teintes Royal Blue

BRUSHES FOR BESTINE
(NOTE: THESE SHOULD BE INEXPENSIVE BRUSHES.)
No. 2 round watercolor • No. 6 round watercolor

BRUSHES FOR WATERCOLOR PENCIL
No. 0 round watercolor • No. 2 round watercolor • No. 4 round watercolor • No. 6 round watercolor • No. 6 round bristle

COLORED PENCILS
See "Color Charts" on pages 24-25 for specific brands and colors.

OTHER
2B graphite drawing pencil • Bestine rubber cement thinner • Colorless blender pencil • Container for water • Cotton balls • Cotton swabs • Desk brush • Electric pencil sharpener, recommended: Panasonic KP-350 (AC, desk model) or KP-4A (battery operated) • Kneaded eraser • No. 16 X-Acto knife blades • Small glass jar with lid (for Bestine) • Small atomizer or pump sprayer • Prismacolor Spray Final Fixative or Krylon Spray Workable Fixative

What Are Colored Pencils?

Because colored pencils look like graphite pencils, are not liquid and are not applied with a brush, many believe that colored pencils are for drawing only. This is completely false. Colored pencil is one of the most versatile of all two-dimensional mediums, and works of art created with colored pencil are paintings, not drawings.

Colored pencils are made of pigments held together with a binder, then hardened and pressed into thin cylinders. The leads are enclosed in wood casing, usually made of cedar. Some colored pencils have no casing and come in sticks that look like pastels. The main categories of colored pencils are distinguished by their binder:

- **Wax-based** is the most common dry colored pencil. The lead ranges from soft and thick to hard and thin. Wax-based pencils break most often and give off the most debris.
- **Oil-based** pencils' pigment is bound together with vegetable oil, resulting in slightly harder leads and less breakage and debris. They are more expensive than wax-based pencils, but because they break less, they last longer.
- **Water-soluble (also known as watercolor pencils)** are identical to dry colored pencils, except an emulsifier is added to the binder, enabling the pigment to be liquefied and used like watercolor.
- **Blender or Colorless Colored Pencils** consist of binder without pigment. These are used to mix colors together. They are also used as a finishing pencil for the burnishing technique (see chapter three).

Colored Pencil Brands

WAX-BASED			
Brand Name	**Manufacturer/Country**	**Lead Type**	**Number of Colors**
Prismacolor	Sanford/USA	Very Soft/Thick	120
Verithin	Sanford/USA	Very Hard/Thin	40
Art Stix	Sanford/USA	Soft/Stick	48
Artist's	Derwent/UK	Soft/Thick	120
Studio	Derwent/UK	Hard/Thin	72
Signature	Derwent/UK	Medium/Thick	60
Fullcolor	Brunyzeel-Sakura/Holland	Soft/Thick	100

OIL-BASED			
Rembrandt Polycolor	Lyra/Germany	Soft/Thick	78
Polychromos	Faber-Castell/Germany	Soft/Thick	120
Pablo	Caran d'Ache/Switzerland	Soft/Thick	120

WATER-SOLUBLE			
Rembrandt Aquarell	Lyra/Germany	Soft/Thick	78
Albrecht Dürer	Faber-Castell/Germany	Soft/Thick	120
Supracolor	Caran d'Ache/Switzerland	Soft/Thick	120
Prismacolor Watercolor	Sanford/USA	Hard/Thick	36
Watercolour	Derwent/UK	Hard/Medium	72
Aqua Monolith	Cretacolor	Medium/Stick	72

Colored Pencil Characteristics

Colored pencils differ from most painting mediums in that the mixing of color is done directly on the paper surface, instead of being mixed on a palette. This is possible mainly because of its unique translucent qualities.

Colored Pencils Are Translucent

Translucent objects or mediums are see-through without being completely clear or transparent. Watercolors are *transparent*; the color on top does not cover the color underneath. Oils, acrylics and pastels are *opaque*; if you paint one color on top of another, the color underneath is hidden. When painting with colored pencil, lighter colors are painted on top of darker colors and both colors are still visible. This unique quality enables artists using colored pencil to create paintings with the appearance of any medium, including colored pencil of course!

You Can't Completely Erase Colored Pencil

The only drawback to working with colored pencil is its resistance to erasing. Colored pencil is nearly impossible to remove completely without damaging your painting surface so much you can no longer use it. Build-ups of pigment can be removed, but a residue or ghost will always remain. The translucence of colored pencil adds to this problem. Dark or strong colors that have been erased will still show through lighter colors applied on top of them. This is why it's important to carefully plan your colored pencil paintings before you begin actually painting.

1

2

3

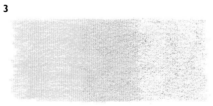

Erasing Colored Pencil
Once you apply a strong layer of color on a paper surface (1), you can't completely erase it. You can remove some of the color, but a residue will remain (2). A lighter color applied on top of that residue produces an impure hue (3).

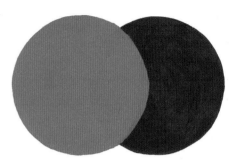

Acrylic Paints are Opaque
You can't see through opaque mediums, such as acrylics, at all. Notice that where the circles overlap, the color underneath is covered over.

Watercolors Are Transparent
Because watercolor paints are completely transparent, where the circles overlap the color underneath combines with the color on top and produces violet.

Colored Pencils Are Translucent
Because colored pencils are not completely see-through, where the circles overlap both the color underneath and the color on top are visible.

Colored Pencil Techniques

Colored pencil artwork employs techniques that may seem unusual to those who have worked in more traditional mediums like watercolor, oil or pastel. Regardless of what technique you use, colored pencil is not a fast medium. It takes time to complete a painting and that's part of the fun.

In this section you'll learn the basic techniques, each suited for specific results. There are many variations. Colored pencil artists experimenting with the medium developed many of the more unusual ones. After working with colored pencil for a while, artists often invent their own techniques—you can, too!

Colored Pencil Basics

These are the basic rules to apply to your work. No matter what other techniques you learn, these should hold true.

- Keep your pencils sharp at all times.
- A sharp point equals smaller coverage and intense color.
- A dull point equals greater coverage and less intense color.
- Light pencil pressure equals less dense color.
- Heavy pencil pressure equals denser color.
- When layering colors, apply the darkest value first with lighter values on top.
- Paint the lightest areas of your painting first when they are next to darker areas to avoid contamination.
- Allow the paper to show through for highlight areas when using white paper.
- Always allow strokes to follow the natural contours of the subject.
- Keep your art, your work area and your hands clean.
- Frequently brush away debris left behind by soft pencils.
- Prevent smudging by keeping your hands away from painted areas.
- Remove smudges as you work by "dabbing" with a kneaded eraser.
- When your painting is complete, spray it with several coats of fixative.

WORDS TO KNOW

TRANSPARENT A medium is transparent when it is completely see-through, as in watercolors.

TRANSLUCENT The quality of being see-through, but not completely transparent.

OPAQUE A medium is opaque when the color on top completely covers any pigment underneath.

How to Apply Colored Pencil: Basic Strokes

There are many ways to apply colored pencil. But circular and linear strokes are most frequently used in colored pencil art. Which stroke to use depends on the subject's size and shape. For example, circular strokes work best for spheres, while you'd probably use a linear stroke to create the look of wood grain.

Hold your pencil in a normal writing position, perpendicular to the paper surface, most of the time. Sometimes you may hold it parallel to the paper to create particular effects. Apply as little pressure as possible with a sharp point, particularly in the early stages of the painting. There will be instances where you'll need to apply heavier pressure with dull points—we'll get to that later.

After mastering the basic strokes, try experimenting with some ideas of your own. You will be surprised at what you can do.

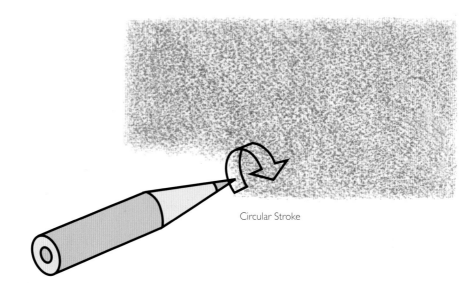
Circular Stroke

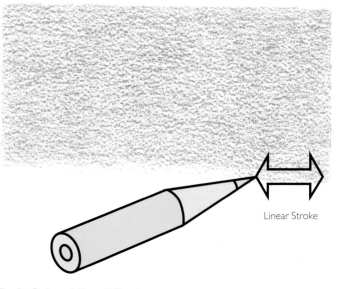
Linear Stroke

Basic Colored Pencil Strokes
Circular strokes are most often used for smooth surfaces and granular textures, such as sand. Linear strokes are used to show strong contours and textures, such as wood grain.

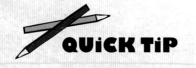

QUICK TIP

BRUSH STROKES IMITATE PENCIL STROKES
Later on, when you begin adding water or solvent using brushes or other applicators, you'll use the same strokes you would when using pencils.

Watch Out For Wax Bloom

Wax bloom is a by-product of using wax-based colored pencils. It is a thin layer of wax that seems to "bloom" after heavy applications of pigment. More pronounced with darker colors, wax bloom can be temporarily removed with a soft cloth. But this only removes the color and allows the bloom to reappear. No matter how many times you wipe off wax bloom, it will keep coming back.

Eliminate Wax Bloom With Fixative

The solution to this problem is simple: When using wax-based colored pencils, spray the art with fixative when it is finished to permanently remove the wax bloom.

- Hold the fixative approximately twelve inches (30cm) from the surface of the paper.
- Keep the can moving at all times to prevent running.
- Allow each coat of fixative to dry completely. Drying times increase after each coat because less of the fixative is absorbed into the paper each time it is applied.

The number of coats required to eliminate wax bloom depends on the size of the artwork. Smaller pieces require only three to four coats, while larger works may require eight to ten and even more if there are large areas of dark color. Colors do not change after adding fixative. After you apply fixative to a painting, you can't add more colored pencil, regardless of whether or not the fixative is workable. Always apply fixatives outdoors; they are toxic and have a strong, lingering odor.

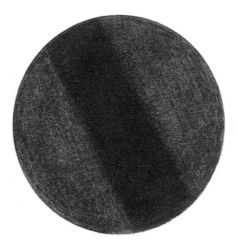

What Does Wax Bloom Look Like?
The whitish haze you see on either side of this dark green circle is wax bloom. Gently buff off the bloom with a soft cloth to remove it, then spray your paintings with fixative to keep it away.

WORDS TO KNOW

FIXATIVE A liquid spray that dissolves the wax and binds pigment to the painting surface, eliminating wax bloom.

WAX BLOOM A thin layer of wax that seems to "bloom" after heavy applications of pigment with wax-based colored pencils.

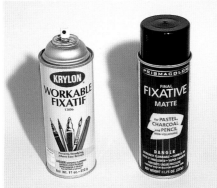

Fixatives That Work For Colored Pencil
Prismacolor Spray Final Fixative, Krylon Spray Workable Fixative and Krylon Crystal Clear are brands I've found that produce good results with colored pencils.

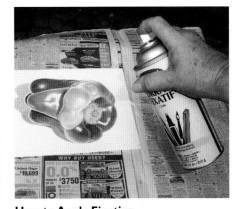

How to Apply Fixative
Hold the can about twelve inches (30cm) away from your paper surface and move the can back and forth across the painting. Don't stop moving your arm as you spray, or the fixative may run, ruining your painting.

Use Solvents for Paint-Like Effects

You can get the paint-like effects of watercolor pencils and watercolors with dry colored pencils using solvents. *Solvents* liquefy the pencil pigment, covering the paper surface quickly. Every solvent affects colored pencil differently, which opens unlimited possibilities, especially when you combine solvents and dry colored pencils with dry and water-soluble colored pencil techniques.

After you apply solvent to a layer of color, subsequent layers of color and solvent will not disturb the layers underneath. The translucent quality of colored pencils will allow you to create subtle hues and values using this technique.

Here are three types of solvent often used with colored pencil.

- **Rubber cement thinner (Bestine)** produces a consistent, smooth blend and dries almost instantly. Because it dries quickly, it works best in small areas applied with a cotton swab or small brush. The brand Bestine is the only brand of rubber cement thinner that seems to work for colored pencil. If you can't find Bestine, it's best to use odorless turpentine.

- **Odorless turpentine** gives you the same smooth, consistent blending as Bestine, but it has a much longer drying time. The longer drying time is helpful when you're working on large areas that require more time for blending. While Bestine may dry before you've blended as much as you want to, odorless turpentine won't. Try applying it to your larger paintings with cotton balls or a soft cloth.

- **Rubbing alcohol (isopropyl)** creates a loose, grainy effect, very different from the other two solvents. You can apply alcohol using the techniques already discussed. The drying time is somewhere between the other two solvents.

There is an unlimited variety of solvents available to experiment with. But no matter what you use, exercise caution with them. Proper handling of solvents will be discussed in more detail in chapter four.

WORDS TO KNOW

COLOR SHIFT The hue change that happens to some watercolor pencils when water is applied and the pigment spreads out on the paper surface.

SOLVENTS Liquids used to dissolve colored pencil pigment, and cover the painting surface quickly.

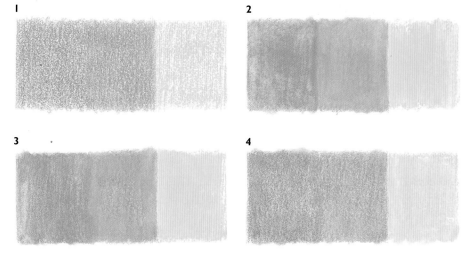

Effects of Solvent on Wax- or Oil-Based Colored Pencils
When you first layer colored pencil, its translucent quality stands out the most (1). Without solvent, both colors are clearly visible and the pigment sits on top of the paper. Adding rubber cement thinner (2) to your layers of color liquifies the pigment, causing it to fill the pores of the paper and to resemble watercolor paints. The colors blend as a result. You can achieve the same effect with odorless turpentine (3), but your job will go much slower because odorless turpentine takes longer to dry. For a grainier effect, try rubbing alcohol (4).

Properties of Watercolor Pencils

Easier to control and more convenient than watercolor paints, watercolor pencils (water-soluble pencils) are also a lot easier on your wallet. The advantage of watercolor pencils over regular colored pencils is that you can cover the paper surface and blend colors without using solvents. You just need water.

Hard or Soft Leads

Lead hardness varies between watercolor pencil brands as it does with their wax- and oil-based counterparts. Soft lead has better coverage and doesn't carve grooves in the paper surface the way harder leads can.

What Happens When You Add Water?

When you add water to dry watercolor pencil pigment, the pigment liquifies and fills the grain of the paper, much as it does when you add solvent to regular colored pencils. Different brands dissolve differently though, and at different rates. Test a few pencils of different brands to see how they react. Choose pencils whose pigment completely dissolves and looks like watercolor when you apply water. A pigment's intensity is usually comparable to how easily it dissolves. Colors should be vibrant and you shouldn't have to apply water too many times to achieve the watercolor look.

Dry to Wet Color Shifts

Some watercolor pencils' colors look different after water is applied than when they are dry because the color changes when it spreads out to cover the paper surface. These color changes or *shifts* are more apparent in stronger colors such as reds, purples, violets and certain earth tones. Color shifts indicate a pigment's quality. Less color shift means a better pencil. So try individual pencils or small sets before making an investment in a large set.

Erasability

When dry, you can erase watercolor pencils about as well as you can erase wax- or oil-based pencils. However, after you add water to the pigment, an eraser will have no effect on it. If you want to remove color at that point, you'll have to add water to lift off the pigment just as you would with watercolor paint.

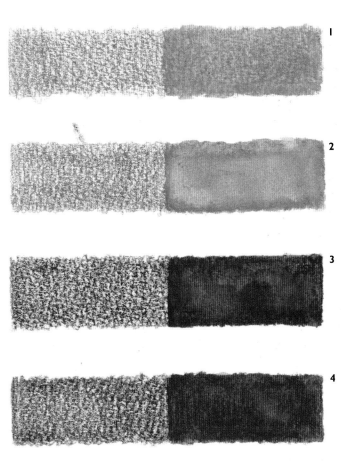

Make Informed Watercolor Pencil Choices

Before you buy watercolor pencils, it's best to try out the different brands. Pigments do not completely dissolve with some (1), no matter how much water you add. And some brands' colors change or shift (3) when you add water. Look for pencils whose pigment completely dissolves when you add water (2) and whose color is the same with or without water (4).

Paper for Colored Pencil

You can apply colored pencil to almost any surface as long as it is not perfectly smooth like glass, porcelain or acetate. There are many different surfaces to experiment with, such as colored paper, watercolor paper, clay board, drafting film (a polyester), hardwood and cloth.

Paper is the most commonly used surface for colored pencil. As a general rule, colored pencil works best on paper with texture, known as *tooth*. The more tooth a surface has, the more texture it has. Final paper choice often depends on what technique you use.

The layering technique (page 30) works well with papers having fine to heavy tooth. With a technique such as burnishing, which requires heavier applications of pigment, you'll need a thicker paper to resist warping and a deeper tooth to hold the pigment.

For most colored pencil painting techniques, look for 4-ply museum board or 3-ply bristol vellum.

✎ **Museum board** has a fine, deep tooth that allows many applications of pigment, required by techniques like burnishing. It's acid-free and is thick enough to resist the warping that heavy applications of colored pencil tends to induce in weaker surfaces. All four plies of paper are acid-free.

✎ **Mat board** is similar to museum board but consists of acid-free paper veneers and a composite nonacid-free core. If too many layers of pigment are applied to mat board, the veneer peels off, ruining the painting. For this reason, you should avoid burnishing on it.

✎ **Illustration board** is similar to mat board. It has virtually no tooth. You cannot burnish on this board either because of the veneer. It's not acid-free, which can pose a threat to your work's longevity. While you can draw or paint on either side of mat board, illustration board has only one drawing surface.

✎ **Bristol vellum's** tooth is coarser and less deep than museum board's. It is an excellent surface for both layering and underpainting techniques.

WORDS TO KNOW

ACID-FREE Paper or materials with a pH of 7. If a surface contains materials with a pH less than 7, the art will eventually decay.

PAPER TOOTH The degree of roughness or smoothness of an artwork surface.

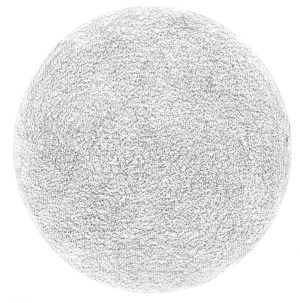

Bristol Vellum
Bristol vellum's coarse and deep tooth holds several layers of colored pencil and makes interesting textures possible for underpaintings.

Paper for Watercolor Pencil

For the most part, watercolor paper is the surface best suited for watercolor pencil. This is not to say that you can't use anything else. Museum board and bristol vellum can be used with minimal amounts of water.

There are many varieties of watercolor paper. It is available in different weights and a wide range of prices. When first starting out, try either cold-pressed or rough watercolor paper. It's easier to make corrections on these.

Types of Watercolor Paper

Hot-pressed watercolor paper is smooth and requires a great deal more control, especially when using more water. It isn't porous, which causes pigment to puddle on the surface.

Cold-pressed and *rough* watercolor papers have more tooth and are much more porous than hot-pressed paper. Cold-pressed and rough paper's tooth is coarser than papers like bristol vellum too. Liquefied pigment can be removed from these papers by "scrubbing" with water and a brush. Even a toothbrush can be used on high-quality rough paper while still allowing the ability to repaint where paint has been lifted.

Weights of Watercolor Paper

Another consideration when choosing a watercolor paper is its weight, which approximately describes its thickness. A paper's weight is determined by how much a *ream* (500 sheets) of that particular paper weighs. Thickness will vary slightly from paper to paper, because some have different densities and moisture content. The most popular weights for watercolor papers are 140-lb.

(300gsm) and 300-lb. (640gsm). It's safe to use 140-lb. (300gsm) paper for paintings that require less water. Just be aware that it may buckle under even moderate applications of water. Although more costly, 300-lb. (640gsm) paper is a better choice for more serious watercolor pencil painting projects.

WORDS TO KNOW

PLY A paper's ply denotes its thickness. Four-ply is four sheets of one-ply paper laminated together.

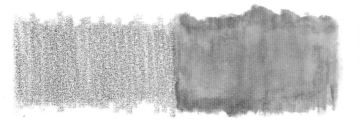

Hot-Pressed Paper
Pressed through heated rollers, this is the smoothest watercolor paper. While it's more difficult to work with, it's excellent for detailed paintings with crisp edges.

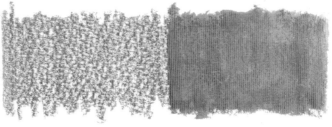

Cold-Pressed Paper
The medium tooth of cold-pressed paper absorbs more water than hot-pressed paper, producing paintings with a looser style and look.

Rough Paper
Rough paper has even more tooth than cold-pressed paper and will hold up to repeated applications of water and pigment removal. This makes correcting mistakes easier than with any other watercolor paper.

Keep Your Pencils Sharp

A pencil sharpener is one of the most important tools in colored pencil art. There are four types of sharpeners. Here are the pros and cons of each.

- **Handheld manual sharpeners** come in many shapes and sizes and are simply constructed, consisting of a body and two blades for sharpening the pencil. Many have replaceable blades and some even have removable containers for shavings. Manual sharpeners are compact, portable and inexpensive. Better models put excellent sharp points on pencils. The main problem with handheld manual sharpeners is time. Colored pencil is a slow medium and using one of these sharpeners will greatly increase the time it takes to complete a painting. Extended use of manual sharpeners can lead to carpal tunnel syndrome as well.

- **Mounted manual sharpeners** put sharp points on pencils of different diameters with a rotating turret of different-sized holes in front of the device. These sharpeners still add considerable time to the completion of artwork. And constantly turning the crank to sharpen pencils may cause a sore arm and shoulder.

- **Battery-operated electric sharpeners** offer efficiency, portability and convenience, but not all models are equal. Some will quickly put a very sharp point on the pencil and are reasonably priced; others are not. Test out a few before buying one if you can.

- **Desktop electric sharpeners** are my first choice for colored pencil. Desktop models are just like their battery-operated brethren except they last longer, are larger and are not as portable. Like battery-operated models, some desktop sharpeners are better than others. Look for a relatively inexpensive model that not only sharpens pencils to a needle-sharp point, but also has an auto-stop feature to prevent wasteful over-sharpening.

QUICK TIP

Electric sharpeners are designed for graphite pencils. They wear out faster when used for the constant sharpening required for colored pencils. Battery-operated pencil sharpeners in particular do not have long life spans and frequently require total replacement. So use your battery-operated sharpener only for travel.

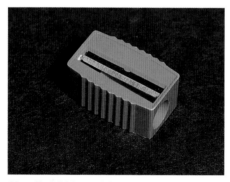

Handheld Manual Sharpener

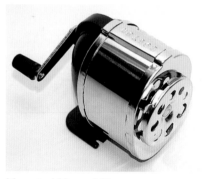

Mounted Manual Sharpener

Desktop Electric Sharpener

Battery-Operated Electric Sharpener

Erasers

As I've mentioned before, you can't completely erase colored pencil without damaging the paper surface. Made of natural and synthetic rubbers, the kneaded eraser is most commonly used for colored pencil because it's very good at removing colored pencil pigment without damaging the paper surface or leaving crumbs. You can also use it to lighten areas by lightly tapping it on the desired area.

Use an imbibed vinyl eraser for heavy-duty work. Imbibed erasers lift pigment without damaging the paper and leave minimal ghosting. You can find them in traditional rectangular cakes and strips for electric erasers. When used in electric erasers, it is possible to "sharpen" imbibed eraser strips into points for erasing tiny areas.

Certain erasers should not be used with colored pencil. Topping the list are hard rubber erasers such as the Pink Pearl. Instead of removing pigment, these severely smudge and grind pigment into the paper surface. Gum erasers are also ineffective and smudge the pigment and leave an excessive number of crumbs. Abrasive, hard rubber ink erasers make the paper surface unworkable for colored pencil.

WORDS TO KNOW

IMBIBED ERASER Available in both eraser cakes and strips for electric erasers, these are treated with erasing fluid that allows them to remove colored pencil marks with light pressure and no damage to your surface.

KNEADED ERASER Soft, rubbery erasers that may be squeezed into any shape and tend not to damage paper surfaces.

Unused In Use

Kneaded Eraser

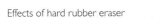

PT 20 KOH-I-NOOR 9600 Imbibed with erasing fluid

Imbibed Erasers and Electric Eraser Strip

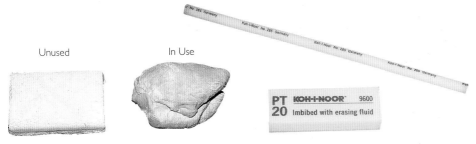

Effects of hard rubber eraser

Effects of gum eraser

Effects of ink eraser

Erasers Not Recommended for Use With Colored Pencil

QUICK TIP

PROTECT YOUR PAINTINGS
Artists' colored pencils have lightfastness qualities comparable to other media on paper. As with other fine art media, certain pigments have more resistance to fading than others. Earth colors, such as gray and other neutral pigments, are more lightfast than red, yellow and purple.

To prevent artwork from fading, don't hang it where it's exposed to direct sunlight for long periods of time and use Plexiglas to avoid the damage if the glass breaks.

Accessories

Along with colored pencils, sharpeners and erasers, there are a few other supplies you'll need to complete your painting toolbox.

Graphite Pencils

A 2B pencil is the best choice for artwork layouts or initial drawings. A 2B is neither too soft for erasure nor hard enough to damage the paper. Use art pencils instead of common graphite pencils, which may have particles in the lead that scratch the paper surface.

Pencil Extenders

These extend the life of pencils when they become too short to be held but are still

Pencil Extenders

Can of Compressed Air

long enough to sharpen. Not all colored pencil brands fit into pencil extenders, so it may be necessary to shave or tape the ends of some pencils so they will fit.

Keep the Work Area Clean

Colored pencils create a lot of dust. If it's not removed from the art surface, it may ruin the painting. For example, debris from a red pencil may lodge in the tooth where yellow is to be added. When you apply the yellow, the red will streak and contaminate the lighter color. To avoid this, clean your work often with a large, soft brush. Drafting brushes are best but any large, soft-bristled brush will work.

You can also use cans of compressed air to blow debris away. Hold the can upright or you'll spray liquid onto your painting instead of air. You can buy cans of air at camera shops or at discount wholesalers.

Brushes

Use round or flat watercolor brushes, with natural or artificial bristles with watercolor pencils. If you intend to use your brushes a lot, brushes with high-quality, natural bristles are a worthwhile investment.

Always use inexpensive brushes with solvents, though. Solvents deteriorate the glue that holds the bristles together, which eventually destroys them.

Other Solvent Applicators

Cotton swabs make excellent solvent applicators. Their compact size and soft texture

Desk Brush

Brushes and Cotton Swabs

Collapsible Water Container

produce smooth blends of color in small areas. Similar blends for larger areas can be made using cotton balls. Try cloth diapers or other soft cloths for the largest areas.

You Need Containers

Whether you work with colored pencils or watercolor pencils, you're going to need containers. For solvents, you'll need small glass jars with narrow necks and tight fitting caps. Glass is the only acceptable container for solvents because many corrode plastic. Most solvents are toxic to some degree and jars with narrow necks allow fewer vapors to escape. Always pour solvents from their original container into a smaller one for easier handling and to prevent contamination. Almost any container will do for water, but collapsible plastic containers are portable and convenient.

Small watercolor palettes can be used with watercolor pencils too. You can break off the points of the pencils, which turn into instant watercolors when you place them in the small palette cups along with water (page 106).

What Colors Should I Use?

For artists new to colored pencil, figuring out what colors to use can be daunting. It will get easier as you become more familiar with the medium. Use one brand at first and then work with others as you learn the colors.

Using several colored pencil brands expands the range of colors at your disposal and gives you the ability to match colors more closely. In some cases, colors with the same name may be a different hue from brand to brand or very similar colors may have different names.

Colored pencils are rarely used alone. They are usually "mixed" to produce vibrant hues. Even experienced colored pencil artists may not able to visualize complex colors consisting of three or more hues, so it is a good idea to try out the combinations you think you will need before starting a painting.

Scarlet Lake (Prismacolor)

Scarlet Lake (Polychromos)

Apple Green (Prismacolor)

Apple Green (Polychromos)

Different Colors Can Share the Same Name

True Blue (Prismacolor)

Dark Phthalo Blue (Polychromos)

QUICK TIP

METALLIC COLORS CAN'T CREATE THE LOOK OF METAL

Most colored pencil manufacturers produce metallic colors such as Gold, Silver and Copper, but these don't work to depict actual metallic subjects. Turn to the demonstration on page 62 to learn to paint metal.

Turn to the demonstration on page 62 to learn to paint metal.

Celadon Green (Prismacolor)

Grey Green (Polychromos)

Some Identical Colors Have Different Names

Color Charts

The following are the colors used in the demonstrations that follow. Use the charts to become familiar with what the colors look like on paper. If you can't find a particular color that's on the list, take the color charts with you to the art store as you look for a good substitute. Swatches for watercolor pencils are shown on page 25 both dry and wet.

QUICK TIP

You can buy pencils in sets or individually (open stock). Buying a set is far less expensive than colors in open stock, but you may need several of one color and never use many of the other colors in the sets. If you get serious about colored pencil, you'll want to buy pencils both in open stock and as sets to keep the sets intact.

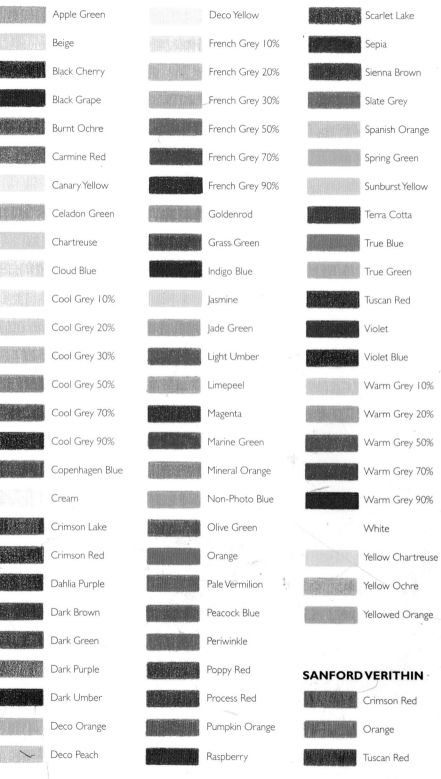

SANFORD PRISMACOLOR

Apple Green	Deco Yellow	Scarlet Lake
Beige	French Grey 10%	Sepia
Black Cherry	French Grey 20%	Sienna Brown
Black Grape	French Grey 30%	Slate Grey
Burnt Ochre	French Grey 50%	Spanish Orange
Carmine Red	French Grey 70%	Spring Green
Canary Yellow	French Grey 90%	Sunburst Yellow
Celadon Green	Goldenrod	Terra Cotta
Chartreuse	Grass Green	True Blue
Cloud Blue	Indigo Blue	True Green
Cool Grey 10%	Jasmine	Tuscan Red
Cool Grey 20%	Jade Green	Violet
Cool Grey 30%	Light Umber	Violet Blue
Cool Grey 50%	Limepeel	Warm Grey 10%
Cool Grey 70%	Magenta	Warm Grey 20%
Cool Grey 90%	Marine Green	Warm Grey 50%
Copenhagen Blue	Mineral Orange	Warm Grey 70%
Cream	Non-Photo Blue	Warm Grey 90%
Crimson Lake	Olive Green	White
Crimson Red	Orange	Yellow Chartreuse
Dahlia Purple	Pale Vermilion	Yellow Ochre
Dark Brown	Peacock Blue	Yellowed Orange
Dark Green	Periwinkle	
Dark Purple	Poppy Red	**SANFORD VERITHIN**
Dark Umber	Process Red	Crimson Red
Deco Orange	Pumpkin Orange	Orange
Deco Peach	Raspberry	Tuscan Red

Wax-Based Colored Pencils

FABER-CASTELL POLYCHROMOS

Dry Wet

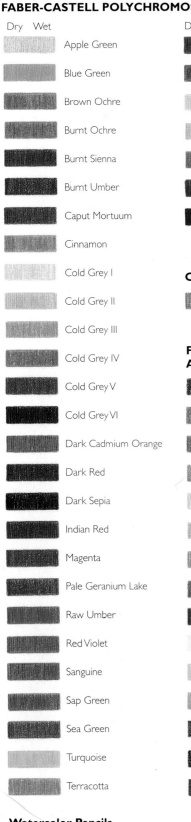

	Apple Green
	Blue Green
	Brown Ochre
	Burnt Ochre
	Burnt Sienna
	Burnt Umber
	Caput Mortuum
	Cinnamon
	Cold Grey I
	Cold Grey II
	Cold Grey III
	Cold Grey IV
	Cold Grey V
	Cold Grey VI
	Dark Cadmium Orange
	Dark Red
	Dark Sepia
	Indian Red
	Magenta
	Pale Geranium Lake
	Raw Umber
	Red Violet
	Sanguine
	Sap Green
	Sea Green
	Turquoise
	Terracotta

Dry Wet

	Van Dyck Brown
	Venetian Red
	Warm Grey I
	Warm Grey II
	Warm Grey IV
	Warm Grey V
	Warm Grey VI

CARAN D'ACHE PABLO

	Brownish Beige

FABER-CASTELL ALBRECHT DÜRER

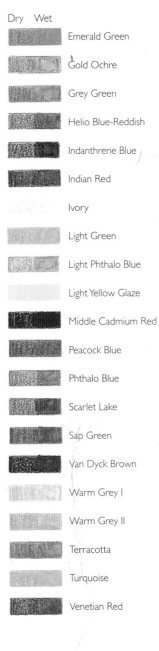

	Alizarin Crimson
	Brown Ochre
	Burnt Ochre
	Cinnamon
	Cold Grey I
	Cold Grey II
	Cold Grey III
	Cold Grey IV
	Cold Grey V
	Cream
	Dark Cadmium Yellow
	Dark Chrome Yellow
	Dark Red
	Dark Sepia
	Deep Cobalt Blue

Dry Wet

	Emerald Green
	Gold Ochre
	Grey Green
	Helio Blue-Reddish
	Indanthrene Blue
	Indian Red
	Ivory
	Light Green
	Light Phthalo Blue
	Light Yellow Glaze
	Middle Cadmium Red
	Peacock Blue
	Phthalo Blue
	Scarlet Lake
	Sap Green
	Van Dyck Brown
	Warm Grey I
	Warm Grey II
	Terracotta
	Turquoise
	Venetian Red

DERWENT WATERCOLOUR

	Flesh Pink
	Raw Sienna

Watercolor Pencils

Using Reference Photos

Good reference photos are an absolute must for colored pencil art, primarily because the paintings take time to complete. Anything perishable will spoil long before a painting is finished. *Plein air*, or painting outdoors, lends itself to sketching with colored pencils. A serious colored pencil painting, however, would be difficult to complete before your scene changed in some way.

While copying photos from magazines, books or the Internet for public display or sale violates copyright laws, it's perfectly acceptable to do so for practice and for personal use. But you'll often find the best reference photos in your own albums. You can even choose particular elements from a copied photo. For example, you can incorporate a tree from one photo into a different composition. Try making composites from two or more reference photos, either by cutting and pasting copies together or using a computer with photo imaging software.

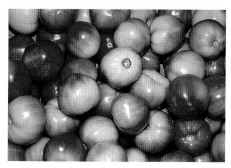

Reference Photo

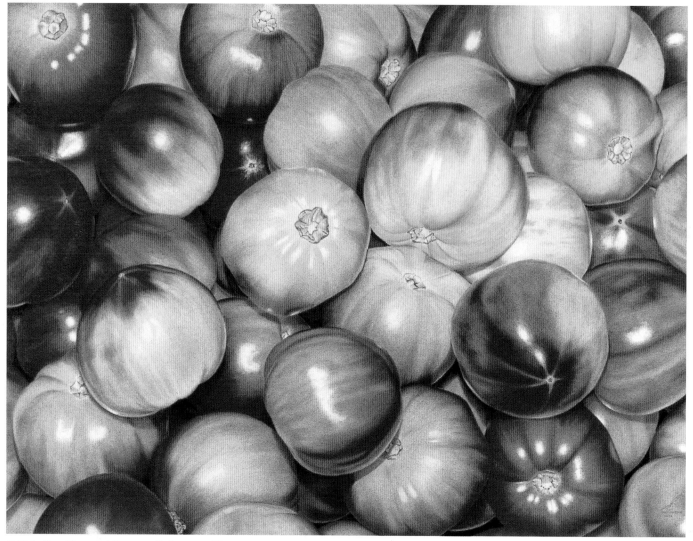

A Painting Created From a Reference Photo

B

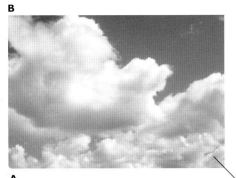

C

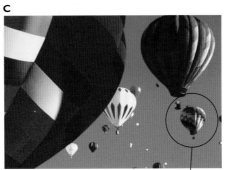

D

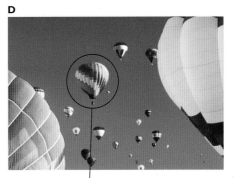

A

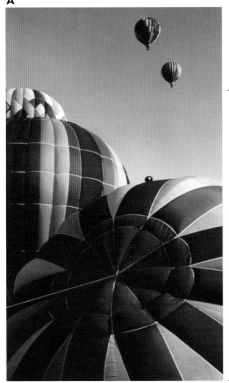

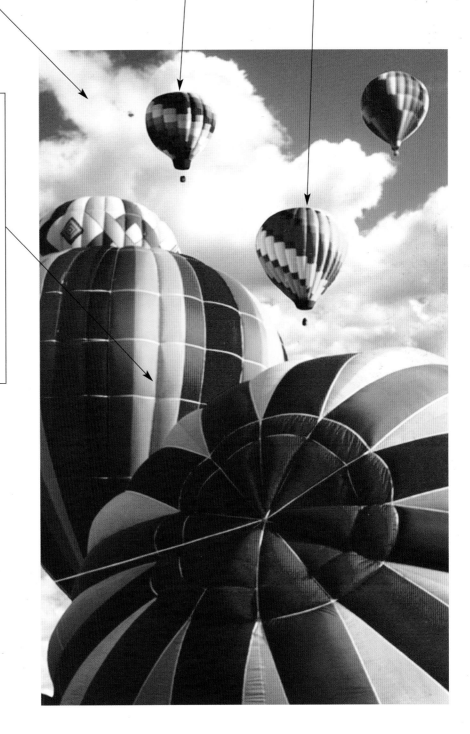

Combine Elements of Different Photos

You're never limited by what appears in your photo. The real fun begins as you combine elements that you like from several photos. Here I selected the original photo (A) because I liked the drama of the large balloon in the foreground playing off the smaller balloons. However, the cloudless sky looked flat, so I added some clouds from another photo (B) and a few more balloons (photos C and D) to add interest to the composition.

How to Begin a Colored Pencil Painting

Whether you're using dry or water-soluble colored pencils, it's always best to begin with a graphite pencil drawing and a colored pencil layout. Two major characteristics that set colored pencil apart from other media, translucency and the inability to erase, make beginning drawings for colored pencil paintings a three-stage operation.

Why is it necessary to go through these extra steps? The preliminary graphite lines are necessary because if you draw your painting with colored pencil first and want to make a change or correct an error, you're stuck. Colored pencil lines cannot be completely erased. They will show through when color is added, especially when using strong or dark colored lines. The graphite lines must be erased because they too would show through when colored pencil is laid on top. Draw your colored pencil lines next to the graphite lines and not on top of them or the graphite will be trapped under the colored pencil, becoming difficult, if not impossible to erase.

For the colored pencil layouts, choose a corresponding Verithin or oil-based pencil that is a little lighter than the area to be painted. Prismacolor pencils don't work as well for this because the sharp point can't be maintained. And you always want a corresponding lighter color so that the outline won't show when your painting's finished.

MATERIALS

PAPER
Any paper

COLORED PENCILS
Verithin, any color

OTHER
2B graphite pencil • Kneaded eraser

1 Draw Graphite Lines
Lightly draw a rough sketch with a sharp 2B graphite pencil. Don't use too much pressure or you'll imprint grooves in the paper that will be visible when you add color.

2 Draw Colored Pencil Lines Next to the Graphite Lines
When you're happy with your graphite drawing, lightly redraw the graphite lines with a Verithin pencil that corresponds to the color of the area to be painted. Draw the colored lines next to, not on top of, the graphite lines.

3 Erase the Graphite and Touch Up the Colored Pencil Lines
Gently erase all the graphite lines with a kneaded eraser. Because colored pencil cannot be completely erased, the colored pencil lines will remain, although some may need to be touched up. You are now ready to paint.

Getting Started

As you get started with colored pencils, the most important thing to remember is to enjoy yourself. Like any endeavor, people are most successful doing things they enjoy. If you are a gardener, then flowers, leaves, bark, birds and insects might be sources for paintings. If traveling and the outdoors interest you, landscapes and related topics provide a wealth of ideas. Your choices are unlimited. If you look closely at your world, you'll never want for ideas. Choose subjects you enjoy, that lend themselves to the medium and, at first, choose subjects that are not complex.

Begin With Easy Subjects

The versatility of colored pencils gives you the freedom to paint anything. Begin with simple subjects that match your skill level. Sometimes people attempt projects that are too difficult, then become disappointed and discouraged. To protect yourself from this, try out what you think are the "difficult" parts of a particular subject on a separate piece of paper before starting a painting. By practicing first, you'll get an idea of how difficult the piece is and whether you have the experience to paint it. It is also a way to determine in advance how to choose and mix the colors you will need for the piece.

Do the Skill-Building Exercises First

In the pages to come, you'll learn the basic colored pencil techniques that you'll use to paint simple subjects. Flowers, fruits and vegetables with lots

Begin With Simple Subjects

of color and simple shapes will build your confidence until you are ready to "graduate" to more difficult projects that may involve multiple techniques or even techniques of your own. Practice the Skill Building Exercises and become familiar with them before attempting the Demonstrations.

The Demonstrations in each chapter combine techniques you've learned previously, both singly and in combination. After you've done some of the Demonstrations, try using different techniques on the same subject so you can make direct comparisons on how different techniques look.

Paint Large

All the demonstration art was painted on 8 ½" x 11" paper, which should be the minimum size of your work. It's difficult to maneuver any smaller than that. The brush sizes should increase proportionally if your art is larger. The line work in color layouts shown for the Demonstrations is drawn much heavier than it needs to be just so you can see them. When you do your own, your lines should be barely visible.

You'll improve with practice, but for now, relax and have fun!

Layering— The Basic Colored Pencil Technique

The foundation of all colored pencil painting is layering. This involves applying colors on top of one another with very little pencil pressure, starting with the darkest values and adding increasingly lighter hues on top. The darkest values are added first because of the translucent quality of colored pencils. Darker colors are visible under lighter colors.

With the layering technique, paper surface shows through the layers of color, so the paper's tooth determines the painting's overall texture. Layering on paper with a fine tooth is suited for tight, detailed paintings, while papers with coarse tooth are ideal for textures such as weathered wood, rocks and other rough surfaces. Slightly harder oil-based colored pencils are best for layering. You can manipulate the appearance, texture and mood of your painting by using surfaces of different colors or textures for your paintings.

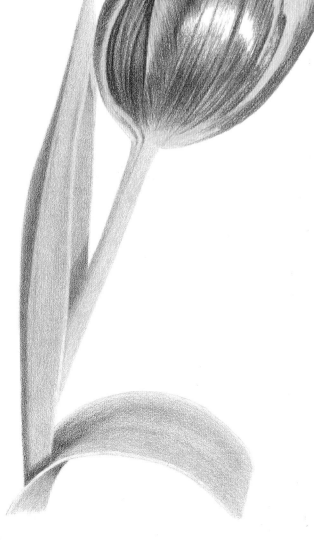

TULIP
Colored pencil on 3-ply bristol vellum
8½" x 11" (22cm x 28cm)

Layer to Paint a Sphere

A simple sphere is the perfect place to get acquainted with layering. Apply small strokes with light pressure and a sharply pointed pencil. Complex colors and textures will build up gradually. The layers of colored pencil you apply sit on top of the tooth of the paper. The sharper your pencil is, the more chance it has of dipping into the valleys.

MATERIALS

PAPER
3-ply bristol vellum

COLORED PENCILS
(Colors are Sanford Prismacolor.)
Carmine Red · Crimson Lake · Scarlet Lake · Tuscan Red

1 Layer Darkest Values First
Using a circular stroke, apply Tuscan Red to the outline of a sphere.

2 Add Lighter Colors Over Darker Values
Layer Crimson Lake, overlapping the previous layer.

WORDS TO KNOW

LAYERING The basic colored pencil technique that involves applying colors on top of each other using light pencil pressure and allowing the paper surface to show through.

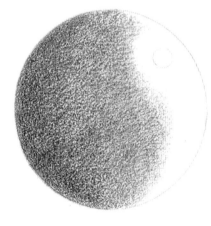

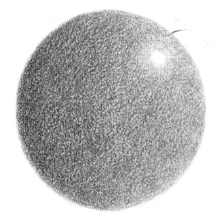

3 Add the Next Value
Continue the overlapping with Scarlet Lake.

4 Complete the Layering
Layer Carmine Red, leaving the paper bare for the highlight.

Use Layering to Create a Landscape

Much of colored pencil painting has to do with building up *values*. Value is the degree of lightness or darkness on a subject. Because color can sometimes distract the eye from value, it's helpful to begin working with values in black and white. You'll learn to use values with just six shades of gray and to evenly apply pigment in this demonstration as you create a *monochromatic* painting, which is a painting done in different shades of the same color. You'll use oil-based colored pencils in this exercise because of their hardness, which creates a finer layered texture and sharper detail for the trees in the foreground.

MATERIALS

PAPER
3-ply bristol vellum

COLORED PENCILS
(Colors are Faber-Castell Polychromos.)
Cold Grey I, II, III, IV, V, VI

OTHER
Kneaded eraser

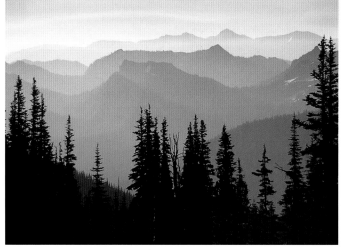

Reference Photo

WORDS TO KNOW

MONOCHROMATIC A painting made up of different shades of the same color.

VALUE The degree of lightness or darkness of a color.

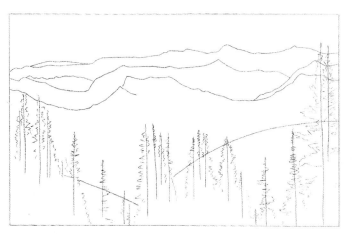

Prepare the Layout With Graphite

Lighten the graphite lines in your line drawing before starting the painting by tapping them with a kneaded eraser until they are barely visible.

2 Paint the Sky

Using very light, horizontal circular strokes, layer the sky with Cold Grey I. Shade from the darkest value (Cold Grey I) at the top to bare paper near the first row of mountains. Lightly blend with a cotton swab. Repeat as necessary to obtain a consistent application of pigment.

In the same manner, layer the first row of mountains with Cold Grey III and II. Graduate from Cold Grey III at the mountain tops to Cold Grey II at the second row of mountains. Then do the third and fourth rows of mountains with Cold Grey IV, III and II. Shade from Cold Grey IV at the mountain tops to Cold Grey II at the bottom of the mountains.

With vertical circular strokes, layer the crest in the right foreground with Cold Grey IV, III and II. Shade from Cold Grey IV at the top of the crest to Cold Grey II at the bottom. Lightly blend with a cotton swab. Repeat as necessary.

In the same manner, layer the crest in the left foreground with Cold Grey V, IV and III. Graduate from Cold Grey V at the top of the crest to Cold Grey III at the bottom.

Using vertical strokes, add the tree silhouettes to the left foreground crest with Cold Grey V.

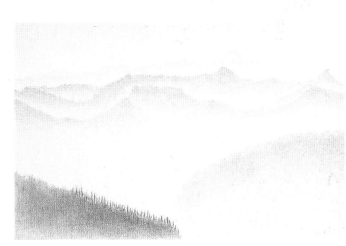

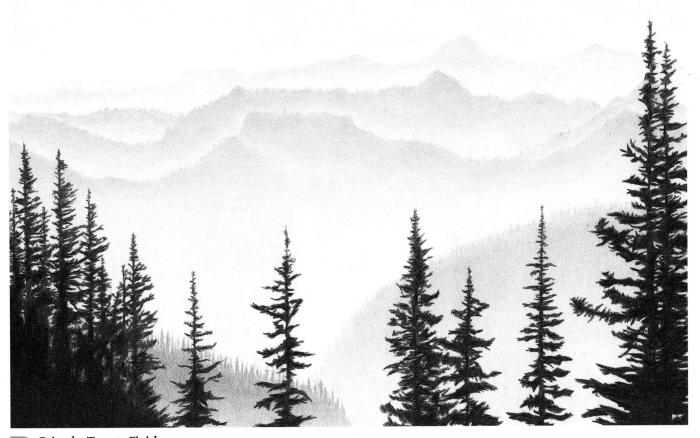

3 Paint the Trees to Finish

Starting at the treetops, burnish heavy linear strokes of Cold Grey VI.

Use Layering to Paint Grapes

To paint the grapes you're basically repeating the sphere exercise from page 31. Purple is a strong color, so you'll paint the stems first to avoid contaminating the lighter colors. To minimize smudging, paint each grape separately, working left to right if you are right-handed; right to left if you are left-handed.

MATERIALS

PAPER
3-ply bristol vellum

COLORED PENCILS
(Colors are Sanford Prismacolor, except where noted.)
Black Grape • Brown Ochre (Polychromos) • Cloud Blue • Cool Grey 30%, 20% and 10% • Cream • Crimson Lake • Dark Purple • French Grey 10% • Light Umber • Magenta (Polychromos) • Red Violet (Polychromos) • Tuscan Red

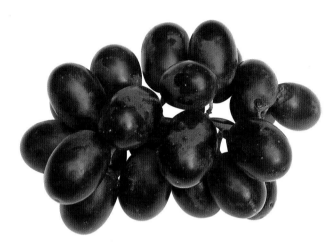

Reference Photo

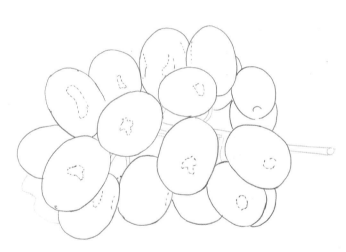

1 **Draw the Layout with Colored Pencil**
Prepare the layout as explained on page 28.

2 **Paint the Grape Stem**
Lightly layer French Grey 10% and Cream on the entire stem. Then add Brown Ochre (Polychromos) and Light Umber.

3 Paint the Grapes

Layer the frosted areas with Cloud Blue. Layer the darkest values with Black Grape or Tuscan Red (not all of the grapes have these dark values). Layer with Dark Purple, Red Violet (Polychromos), Magenta (Polychromos) and Crimson Lake, leaving the paper free of color for the highlights.

Very lightly layer secondary highlights with either Red Violet (Polychromos) or Magenta (Polychromos). Leave highest highlight free of color. Very lightly layer Red Violet (Polychromos) over frosted areas.

Draw the small "button" on some grapes with Brown Ochre (Polychromos).

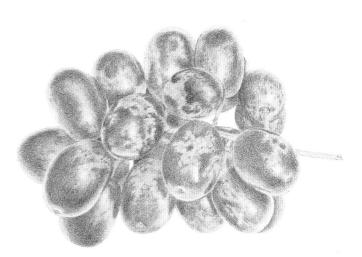

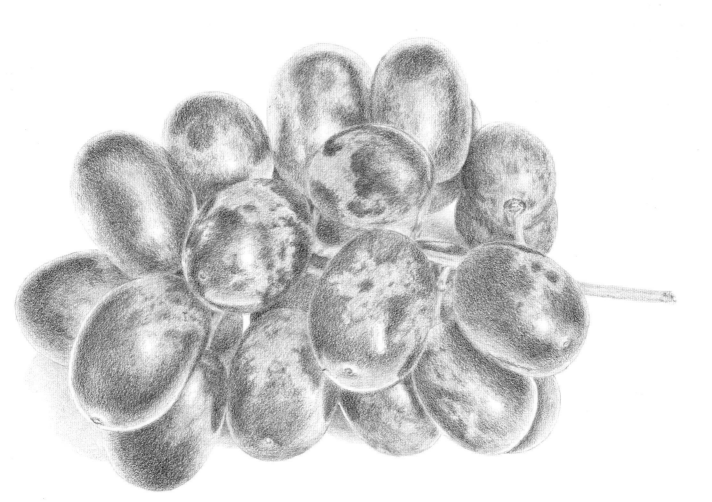

4 Paint the Shadows to Finish

Layer the shadows with Magenta (Polychromos), Cool Grey 30%, 20% and 10%.

Use Layering to Paint a Tulip

This demonstration begins to move into more complicated subjects, though you're still creating the different values you see by simply layering colors. Substitute yellow for the white in the tulip blossom to make this herald of spring more colorful.

MATERIALS

PAPER
3-ply bristol vellum.

COLORED PENCILS
(Colors are Sanford Prismacolor except where noted.)
Apple Green • Cool Grey 90% • Cream • Crimson Lake • Dark Green • French Grey 50% • Goldenrod • Jade Green • Olive Green • Pale Geranium Lake (Polychromos) • Scarlet Lake • Spanish Orange • Spring Green • Sunburst Yellow • True Green • Tuscan Red

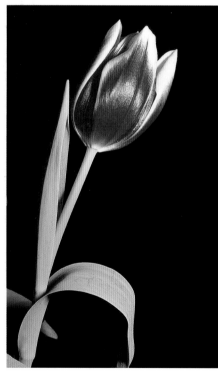

Reference photo

1 Draw the Layout with Colored Pencil
Prepare the layout as explained on page 28.

2 Paint the Yellow Shadows
Layer the darkest yellow shadow areas with French Gray 50% and Goldenrod. Layer the lighter shadows with Goldenrod.

3 Paint the Yellow Petal Areas and Red Shadows
Layer the yellow portion of the petals with Spanish Orange and Sunburst Yellow in the darker areas, including the shadows. Layer the darkest red shadow areas with Tuscan Red.

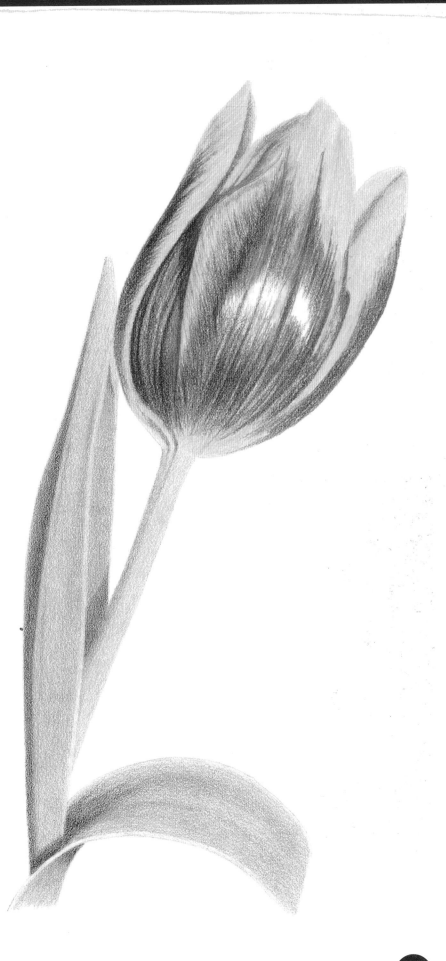

4 Paint the Red Area

Using linear strokes, layer the red area of the petals with Crimson Lake, Scarlet Lake and Pale Geranium Lake (Polychromos). Leave the highlight white. Close the gaps between red and yellow areas with Sunburst Yellow.

5 Complete the Leaves and Stem to Finish

Layer the shadow areas of the leaves with Cool Grey 90% and Dark Green. Layer the leaves with Jade Green, True Green, Apple Green and Cream. Apply all but the Cream over the shadow areas. Lightly layer the darkest value of the stem with Olive Green. Layer the entire stem with Spring Green and Cream.

Use Layering to Paint a Rose

This rose has many subtle hues, making it a perfect subject for colored pencil.

MATERIALS

PAPER
3-ply bristol vellum

COLORED PENCILS
(Colors are Sanford Prismacolor except where noted.)
Apple Green • Burnt Ochre • Carmine Red • Cool Grey 10% • Cream • Crimson Lake • Crimson Red • Dark Green • Deco Orange • Deco Peach • Limepeel • Olive Green • Orange • Pale Vermilion • Poppy Red • Scarlet Lake • Spanish Orange • Sunburst Yellow • Terracotta (Polychromos) • True Green • Tuscan Red • Warm Grey 90% • Yellowed Orange

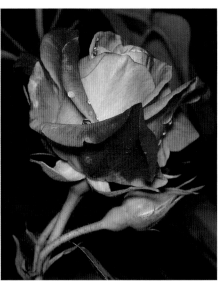

Reference photo

1 Draw the Layout with Colored Pencil
Prepare the layout as explained on page 28.

2 Painting the Rose's Shadows
Layer the darkest orange shadow areas with Burnt Ochre and Terracotta. Layer the darkest red shadow areas with Tuscan Red and Crimson Lake.

3 Add the Dark Values in the Orange Petals
Layer Orange in appropriate areas of the petals, including the orange shadows.

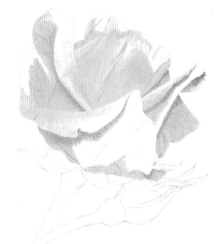

4 Paint the Orange Petals
Layer Yellowed Orange, Spanish Orange, Sunburst Yellow and Deco Orange using linear or circular strokes. Reapply Terracotta (Polychromos) and Orange to enhance the shadows.

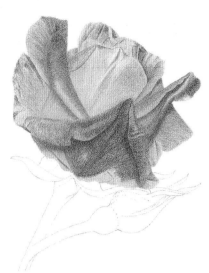

5 Paint the Red Petals

Layer Crimson Lake for the darkest values. Layer Crimson Red, Scarlet Lake, Poppy Red, Carmine Red and Pale Vermilion variously to red petal areas. Tie red areas to orange areas with Pale Vermilion, Orange, Yellowed Orange and Deco Peach. Reapply Tuscan Red and Terracotta (Polychromos) to enhance the shadows.

6 Paint the Leaves, Stems and Buds to Finish

Layer Warm Grey 90% and Dark Green on the darkest cast shadow areas on the stem, under the bloom. Layer Dark Green and Olive Green on the other cast shadow areas. Layer the darkest values on the leaves with Olive Green. Layer the top of leaves with Limepeel, True Green, Cool Grey 10% and Cream. Layer the bottom of the leaves with Olive Green and Limepeel. Layer touches of Tuscan Red to leaves. Layer the stems with Limepeel and True Green. Layer Olive Green, Apple Green, Tuscan Red, Limepeel, True Green, Cream, Sunburst Yellow and Poppy Red on the buds.

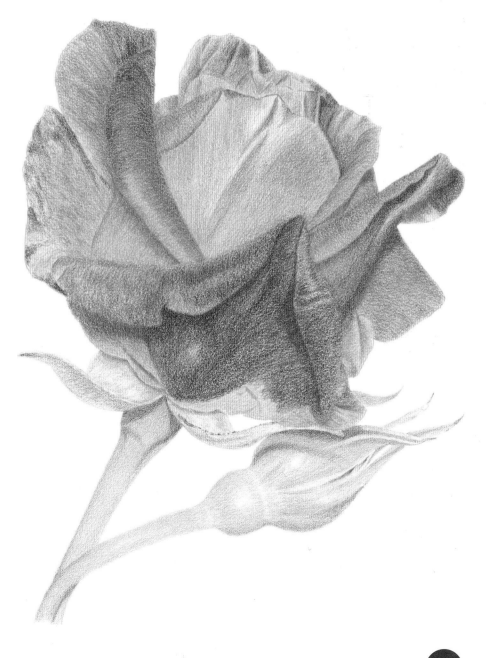

Layer Color on Colored Paper

Because of its translucence, colored pencil works well with colored paper. The color of the paper becomes a part of the painting. You'll use the most extreme background for this demonstration—black. You're working in reverse when using black or another dark surface. Instead of allowing the paper to show through for the highlights, you allow it to show through for the darkest values.

You'll apply fine, linear strokes to depict Grrtrude's smooth coat. To show animal fur that is coarser, use heavier strokes that are farther apart.

MATERIALS

PAPER
Black 4-ply
museum board

COLORED PENCILS
(Colors are Sanford Prismacolor.)
Burnt Ochre • Crimson Red • French
Grey 70%, 50% and 10% • White

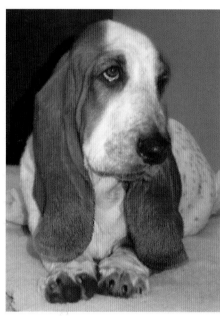

Reference Photo

Draw the Layout with Colored Pencil
Prepare the layout as explained on page 28.

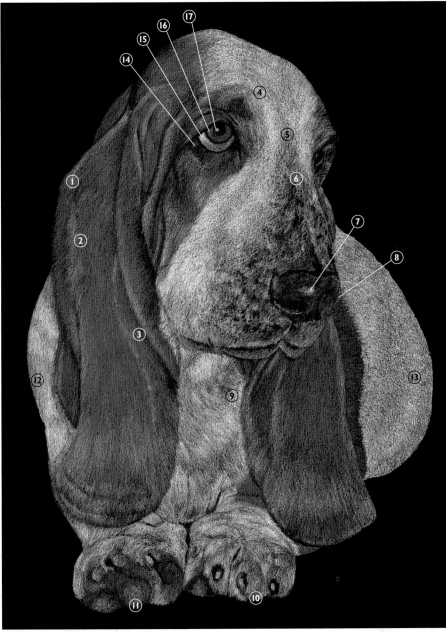

Paint the Nose

7 Use the circular stroke to lightly layer French Grey 10% to the highlight.

8 Use the circular stroke to lightly layer French Grey 50% and 70%, leaving the darkest areas.

Paint the Chest

9 With a linear stroke, layer Burnt Ochre and French Grey 10% and 50%. Use less color in the darkest areas.

Paint the Feet

10 With the linear stroke, layer Burnt Ochre and French Grey 10%, 50% and 70%, leaving the nails.

11 With a linear stroke, lightly layer French Grey 70% and 50% for the pads.

Paint the Body

12 With the linear stroke, layer White, French Grey 70% and 10% to the left shoulder.

13 Layer the body with White using the linear stroke. Apply less pigment to the dark areas and Burnt Ochre to the spots.

Paint the Eyes

14 With a short, linear stroke, lightly layer the lower eyelid with French Grey 70%, leaving the darkest areas.

15 Layer the white of the eye with White and Crimson Red.

16 Apply Burnt Ochre to the iris.

17 Apply White to the highlight.

2 Layer the Colors

Follow the step progression below. When using dark paper, reverse the "darkest value first" rule. Apply the lightest values first and use bare paper for the darkest shadows.

Paint the Brown Areas of the Ears, Head and Face

1 With short, linear strokes, apply French Grey 10% to the highlights.

2 Use long, linear strokes to cover these with Burnt Ochre, leaving the paper free of color in the shadows.

3 Lightly layer the lighter shadows with Burnt Ochre.

Paint the Forehead, Blaze and Muzzle

4 Using a linear stroke, layer French Grey 50% and White.

5 Layer White to the blaze and muzzle with linear strokes, using less white in the darker areas.

6 Use the circular stroke to layer French Grey 50%, 70% and Burnt Ochre around the nose, leaving the darkest areas.

Use Layering to Create a Multi-Textured Still Life

You'll learn to depict objects with different textures in this demonstration: The smooth variegated skin of the watermelon contrasts with its rough textured fruit, a metal knife and a ceramic plate. You can paint all these textures with the layering technique.

MATERIALS

PAPER
3-ply bristol vellum

COLORED PENCILS
(Colors are Sanford Prismacolor.)
Apple Green • Burnt Ochre • Carmine Red • Cream • Crimson Lake • Dark Umber • French Grey 70%, 50%, 30%, 20% and 10% • Grass Green • Jasmine • Pumpkin Orange • Scarlet Lake • Sepia • Sienna Brown • True Green • Tuscan Red • Warm Grey 90%

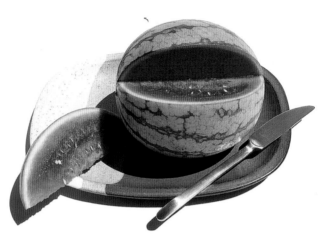

Reference photo

Draw the Layout With Colored Pencil
Prepare the layout as explained on page 28.

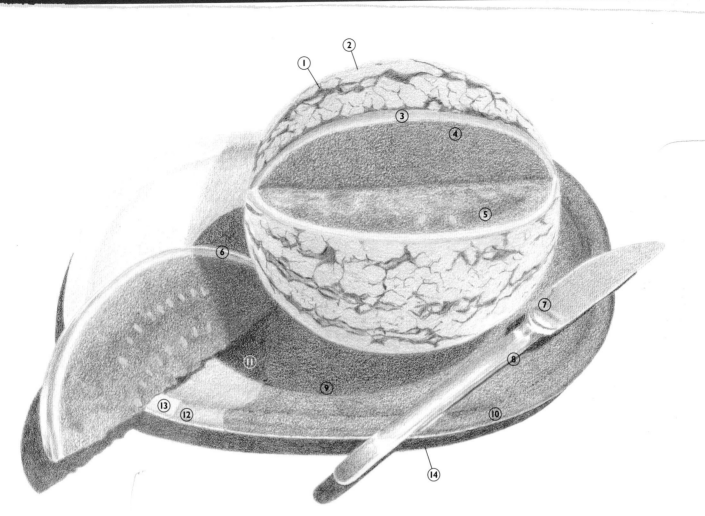

2 Layer the Colors

Follow the step progression below. Note that you always apply the darkest colors first when layering.

Paint the Watermelon

1 Layer and draw the skin's dark variegations with Grass Green.
2 Layer the skin with True Green, Apple Green and Cream.
3 Layer the rind with French Grey 10% (upper cut only), Apple Green and Cream.
4 Layer the inside with Crimson Lake (upper cut and the cast shadow on the wedge only), Scarlet Lake and Carmine Red.
5 Layer the seeds with Jasmine.
6 Layer the cast shadow on the wedge with French Grey 50% on the green and cream areas and Tuscan Red on the red area.

Paint the Knife

7 Layer the watermelon reflection with True Green.
8 Layer the knife, as shown, with French Grey 70%, 50%, 30% and 10%, leaving the highlights free of color.

Paint the Plate

9 Layer the cast shadows on the brown portion with Dark Umber.
10 Layer the brown portion, including the cast shadows, with Sepia (darkest values only), Sienna Brown, Burnt Ochre and Pumpkin Orange. Layer over cast shadows. Leave highlight on the edge free of color.
11 Layer the cast shadows on the taupe portion of the plate with Scarlet Lake (on the cast shadow by the watermelon wedge only) and Sepia.

12 Layer the taupe portion of the plate with French Grey 30%.
13 Layer the lightest area of the plate with French Grey 20% and 10%.
14 Layer cast shadows with Scarlet Lake (areas next to the watermelon wedge only) and Warm Grey 90%.

CHAPTER THREE

Burnishing—The Painterly Technique

The burnishing technique takes layering to the next dimension, producing paintings that look as if they were done in oil, acrylic or even airbrush. People are amazed that burnished paintings are done with colored pencil. It starts where layering stops. After you layer the colors, you use a white or light colored pencil to *burnish*, or mix the colors together except in the very darkest shadow areas. Then you reapply the same colors, except the darkest shadow values, on top. Burnish again and repeat the process until the paper surface is completely covered with pigment.

Restraint is the most important thing to remember when burnishing. Add the color lightly, especially the darkest values that you add first. As you build up the the pigment, gradually add more pressure until you add the final layers, which may require considerable pressure. Equally important to this technique is using a toothy paper surface. The tooth gives the many layers of pigment something to hang onto. If you attempt to burnish on a smooth surface, the pigment will move around after only a few layers.

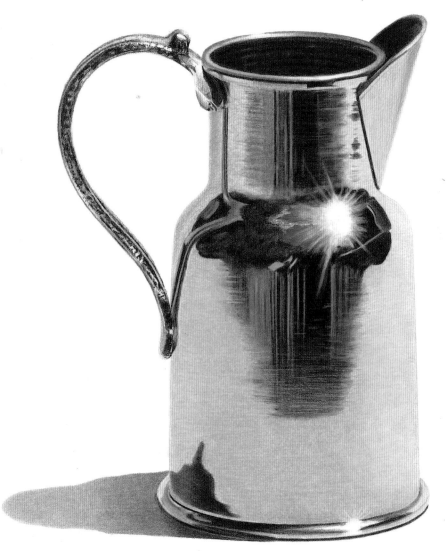

BRASS PITCHER
Colored pencil on 3-ply bristol vellum
8½" x 11" (22cm x 28cm)

Practice Burnishing

Keep your pencil point sharp as you burnish in order to deliver the pigment into the grooves of the paper's tooth. If the point is allowed to wear down, you will instinctively use more pressure to cover the paper with pigment and get poor results. You can use light color to burnish, such as gray, cream, light yellow, light blue or a colorless blender.

MATERIALS

PAPER
3-ply bristol vellum

COLORED PENCILS
(Colors are Sanford Prismacolor except where noted.)
Burnt Ochre (Polychromos) • Orange • Pumpkin Orange • Spanish Orange • Terracotta (Polychromos) • White • Yellowed Orange

OTHER
Colorless blender

WORDS TO KNOW

BURNISH The layering and blending of wax- or oil-based colored pencils until the entire paper surface is covered.

1 Layer the Colors
Using a circular stroke and light pressure, layer Burnt Ochre (Polychromos), Terracotta (Polychromos), Pumpkin Orange, Orange, Yellowed Orange and Spanish Orange. Use more layers to create the darker values and fewer layers for the lighter values.

2 Burnish With White
Use the White pencil with slightly increased pressure to burnish all except the darkest values.

3 Reapply Colors to Finish
Using light pressure, reapply Terracotta (Polychromos), Pumpkin Orange, Orange, Yellowed Orange and Spanish Orange. Increase the pressure again to burnish all (including the darkest values) with the colorless blender.

Burnish With White to Paint a Bell Pepper

Bell peppers, especially the red variety, have fascinating shapes and, if you look for the right ones, gorgeous coloring. There are many subtle hues in this study that lend themselves perfectly to the burnishing technique. Leaving bare paper for the highlights results in shiny surfaces and eye-popping dimensionality. The shadow is layered only and not burnished so it doesn't distract from the pepper.

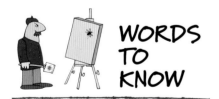

MATERIALS

PAPER
3-ply Bristol vellum

BRUSHES
No. 1 round

COLORED PENCILS
(Colors are Sanford Prismacolor except where noted.)
Apple Green • Beige • Brown Ochre (Polychromos) • Burnt Ochre (Polychromos) • Carmine Red • Chartreuse • Cool Grey 70% • Cream • Crimson Lake • Crimson Red • Dark Green • Dark Sepia (Polychromos) • Goldenrod • Indigo Blue • Limepeel • Olive Green • Orange • Pale Vermilion • Poppy Red • Scarlet Lake • Spanish Orange • Terracotta (Polychromos) • True Green • Tuscan Red • Van Dyck Brown (Polychromos) • Warm Grey 70% • White • Yellow Ochre

OTHER
Bestine • Colorless blender

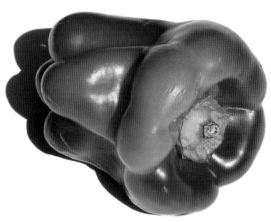

Reference Photo

WORDS TO KNOW

SECONDARY HIGHLIGHT
A highlight that is not as white as the lightest highlight value.

Draw Layout With Colored Pencil
Prepare the layout as explained on page 28.

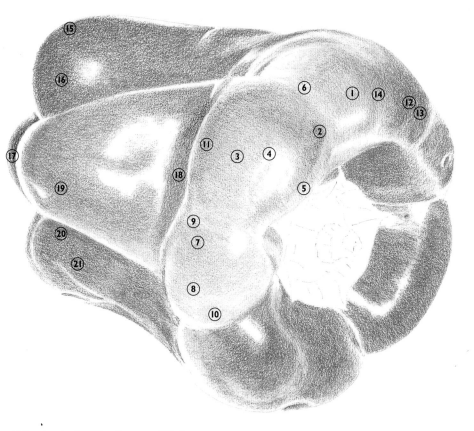

2 Apply the First Layers of Color

1 Layer the yellow ochre area at the front and top with Brown Ochre (Polychromos), Goldenrod, Yellow Ochre and Spanish Orange. Leave the highlight.

2 Create the darkest green values at the front with Dark Green and Apple Green.

3 Layer Apple Green and Limepeel for middle values in the green area.

4 Apply Limepeel for the light value in the green area around the highlight.

5 Use True Green for the light value in the green area to the left of the highlight. Leave the highlight.

6 Layer Spanish Orange and Chartreuse between the green and yellow ochre areas.

7 Layer Limepeel and Yellow Ochre for the darker values of the lower front green area.

8 Lightly apply Limepeel in the lower front, then smudge with a cotton swab.

9 Layer Terracotta (Polychromos) and Orange between the dark and light green areas.

10 Lightly apply Orange over the Limepeel/Yellow Ochre area.

11 Layer Pale Vermilion and Orange to the left of the green area, leaving the edge.

12 Layer Scarlet Lake for the darkest values on the front red areas.

13 Layer Poppy Red and Carmine Red to the front red areas. Leave the highlights.

14 Layer Pale Terracotta (Polychromos), Pale Vermilion and Goldenrod between the red and yellow in front.

15 Layer Crimson Lake to the darkest values of the top rear section.

16 Layer Crimson Red, Scarlet Lake, Poppy Red and Pale Vermilion. Leave the highlights.

17 Layer Tuscan Red and Crimson Lake to the small section at center rear.

18 Layer Dark Green, Olive Green, Burnt Ochre (Polychromos), Terracotta (Polychromos), Pale Vermilion and Orange to the cast shadow in front of the center rear.

19 Layer Olive Green, Terracotta (Polychromos), Pale Vermilion and Orange to the center rear section. Leave the highlights.

20 Layer Crimson Lake and Crimson Red to the cast shadow of the lower rear section.

21 Layer Crimson Red, Scarlet Lake, Poppy Red and Carmine Red to the lower rear. Leave the the highlights.

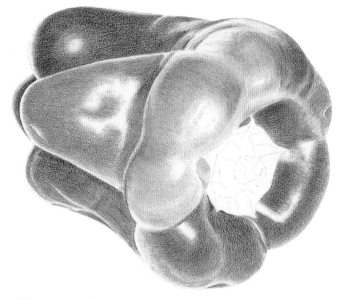

3 **Burnish With White**
Burnish the entire pepper with White, except for the darkest (shadow) and lightest (highlight) values. Drag the adjacent colors into the secondary highlights with White.

4 **Reapply Color**
Using slightly more pressure, repeat step 2, except for the very last item. Lightly add color to the secondary highlights.

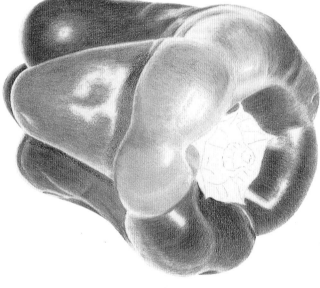

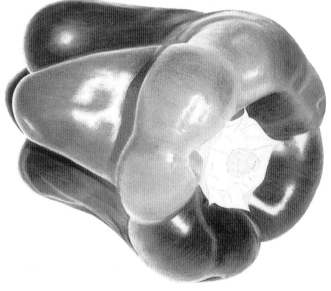

5 **Burnish With White Again and Underpaint the Stem**
Again, burnish the entire pepper with White, except for the darkest (shadow) and lightest (highlight) values to further mix the colors and cover the paper surface.

Apply a layer of Beige to the stem and apply Bestine with a no. 1 round. Be careful not to drag adjacent colors into the beige area.

6 **Complete the Final Layer of Color**
Repeat step 2 except for the final layering, then burnish with a colorless blender pencil until the entire paper surface, except for the highlights, is hidden.

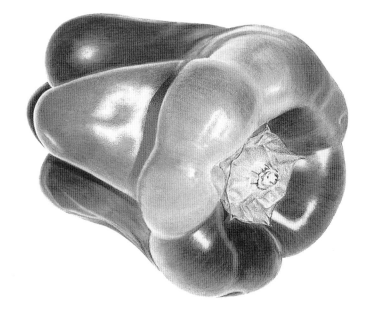

7 Complete the Stem

Layer the stem with Olive Green (darkest green areas only), Apple Green, True Green, Limepeel, Dark Sepia (Polychromos), Van Dyck Brown (Polychromos) and Burnt Ochre (Polychromos).

Burnish all but the darkest and lightest areas with Cream.

Reapply the Olive Green, Apple Green, True Green, Limepeel, Van Dyck Brown (Polychromos) and Burnt Ochre (Polychromos), adding a very light layer of Dark Sepia (Polychromos) to the sides of the center protrusion.

Burnish all with a colorless blender.

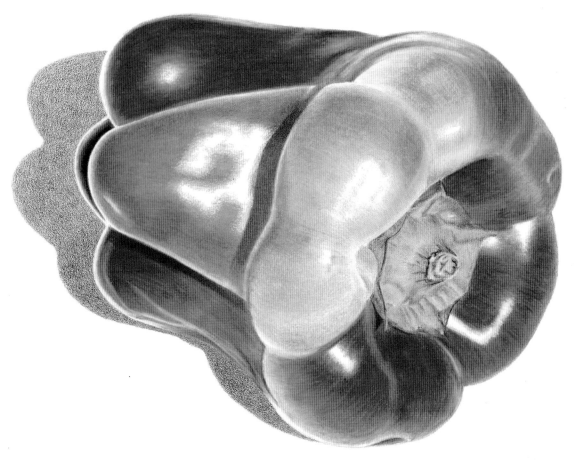

8 Paint the Shadow to Finish

Layer Warm Grey 70% in the red area of the shadow and Cool Grey 70% in the blue area. Layer Crimson Red over the Warm Grey and Indigo Blue over the Cool Grey. Reapply the Warm Grey 70% in the shadow's red area, Cool Grey 70% in the blue area and you're finished!

Burnish With White to Paint a Bottle

The subtle hues of red, orange and yellow swirled, reflected and refracted in this glass bottle make an interesting subject. Your bottle doesn't have to look exactly like the demo because many bottles are handmade, making them all different.

MATERIALS

PAPER
3-ply bristol vellum

COLORED PENCILS
(Colors are Sanford Prismacolor, except where noted.)
Cool Grey 50%, 30% and 10% • Crimson Lake • Crimson Red • Crimson Red (Verithin) • Dark Red (Polychromos) • Dark Umber • Orange • Orange (Verithin) • Pale Vermilion • Poppy Red • Pumpkin Orange • Scarlet Lake • Spanish Orange • Terracotta (Polychromos) • Tuscan Red • Tuscan Red (Verithin) • White

OTHER
Colorless blender

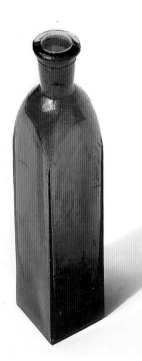

Reference Photo

Draw the Layout With Colored Pencil
Prepare the layout as explained on page 28.

2 Apply the First Layers of Color

Starting at the top of the bottle with the darkest values first, apply the following colors in the order in which they appear below using small circular strokes. Leave the paper free of color for the primary highlights and layer very lightly for the secondary highlights.

1 Tuscan Red
2 Spanish Orange
3 Terracotta (Polychromos), Orange
4 Dark Umber, Tuscan Red
5 Pumpkin Orange, Terracotta (Polychromos)
6 Poppy Red, Pumpkin Orange, Terracotta (Polychromos)
7 Pale Vermilion, Pumpkin Orange, Terracotta (Polychromos), Orange
8 Poppy Red, Pale Vermilion, Terracotta (Polychromos), Orange
9 Pumpkin Orange, Terracotta (Polychromos), Orange
10 Crimson Red, Scarlet Lake, Poppy Red
11 Orange, Spanish Orange
12 Scarlet Lake, Crimson Red
13 Dark Umber, Tuscan Red
14 Crimson Red, Scarlet Lake, Poppy Red
15 Orange, Spanish Orange
16 Dark Umber, Tuscan Red, Crimson Lake
17 Dark Umber, Tuscan Red
18 Scarlet Lake, Poppy Red, Pale Vermilion, Terracotta (Polychromos), Orange
19 Poppy Red, Pumpkin Orange, Terracotta (Polychromos), Orange
20 Crimson Red, Scarlet Lake, Poppy Red
21 Pumpkin Orange, Terracotta (Polychromos)

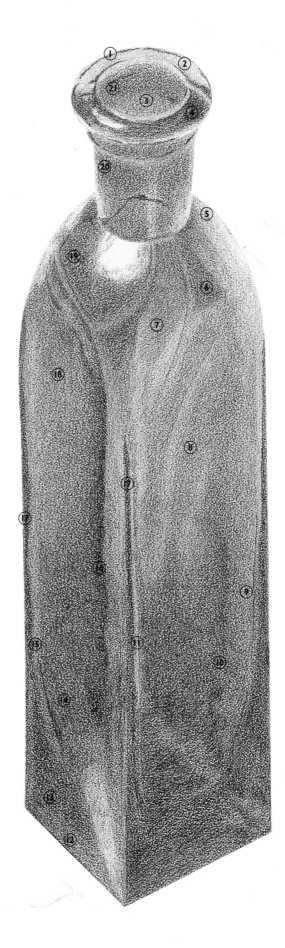

3 Burnish With White

Burnish all but the darkest areas (Dark Umber, Tuscan Red, Crimson Lake) and highlights (bare paper) with White. Lightly burnish dark areas with Dark Red (Polychromos).

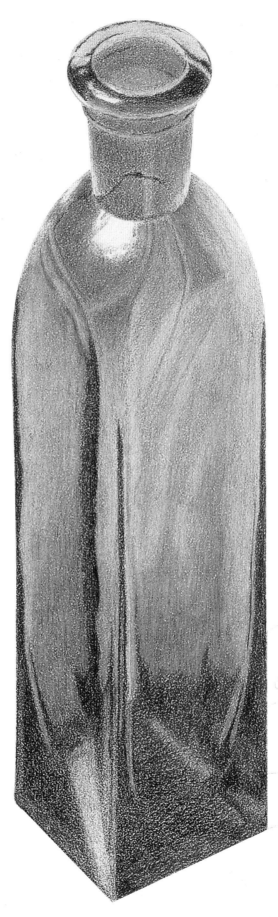

4 Finish the Bottle and Paint the Shadow

Burnish the colors as in step 3 until paper is completely covered. Burnish any remaining specks of paper surface with a colorless blender.

Burnish the secondary highlight at the bottom left side with White. Clean up edges with Tuscan Red (Verithin), Crimson Red (Verithin) or Orange (Verithin).

For the shadow, lightly layer Cool Grey 50%, 30%, 10% and Scarlet Lake. Blend the colors with a dry cotton swab. Keep adding the grays and Scarlet Lake and blending until the color is smooth and uniform.

Burnish With Color to Paint a Banana

An ordinary, everyday banana can be an exciting subject because of its subtle hues of yellow that only colored pencil can capture successfully.

MATERIALS

PAPER
3-ply bristol vellum

COLORED PENCILS
(Colors are Sanford Prismacolor, except where noted.)
Beige • Brown Ochre (Polychromos) • Canary Yellow • Cool Grey 30%, 20% and 10% • Cream • Dark Sepia (Polychromos) • Dark Umber • Deco Yellow • French Grey 50% • Goldenrod • Limepeel • Spanish Orange • Sunburst Yellow

OTHER
Colorless blender

Reference Photo

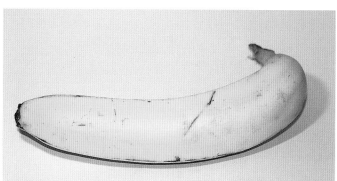

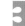

1 Draw the Layout with Colored Pencil
Prepare the layout as explained on page 28.

2 Layer the Foundation Colors
Using small circular strokes, lightly apply French Grey 50% and Goldenrod to the darkest areas of the banana. Using strokes that follow the length of the banana, layer Spanish Orange, Sunburst Yellow, Canary Yellow and Deco Yellow. Then lightly layer Limepeel to the right end only.

3 Burnish the Banana
Burnish the entire banana with Cream.

4 Reapply the Color

Reapply Spanish Orange, Sunburst Yellow, Canary Yellow and Deco Yellow, then burnish with Cream again. Repeat this process until no paper shows through the painted areas.

5 Add the Details and Shadow

Burnish the left tip with Dark Sepia (Polychromos), Dark Umber and Brown Ochre (Polychromos). Burnish the peel spots with Dark Umber and Brown Ochre (Polychromos). Burnish the right tip with Beige, Dark Sepia (Polychromos), Dark Umber and Brown Ochre (Polychromos). Burnish both tips with a colorless blender pencil.

Layer the shadow with Cool Grey 30%, then 20%. Burnish the shadow with Cool Grey 10%. Finally, burnish the shadow with colorless blender.

Burnish With Color to Paint a Dahlia

Using a pale color to burnish, instead of white or a neutral color, captures the brilliance of this dahlia's petals. Another lesson in this demonstration is to simplify. The intricate details of the center are simplified with no loss to the dahlia's integrity. The leaves and stem are layered instead of burnished to more closely resemble the actual texture.

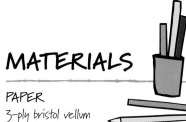

MATERIALS

PAPER
3-ply bristol vellum

COLORED PENCILS
(Colors are Sanford Prismacolor, except where noted.)
Burnt Ochre (Polychromos) • Dark Green • Deco Orange • Deco Yellow • French Grey 30% and 10% • Goldenrod • Limepeel • Olive Green • Orange • Pale Vermilion • Poppy Red • Scarlet Lake • Spanish Orange • Sunburst Yellow • Terra Cotta • Terracotta (Polychromos) • Warm Grey 70% • Yellowed Orange

OTHER
Bestine • Colorless blender • Cotton swab

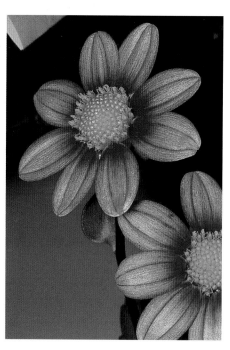

Reference Photo

You'll also get a preview experience with solvent in this demonstration, though the majority of solvent lessons are to come in chapter four.
(NOTE: Terra Cotta=Prismacolor, Terracotta=Polychromos)

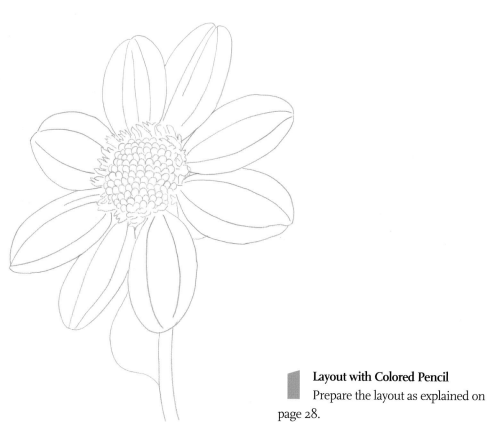

Layout with Colored Pencil
Prepare the layout as explained on page 28.

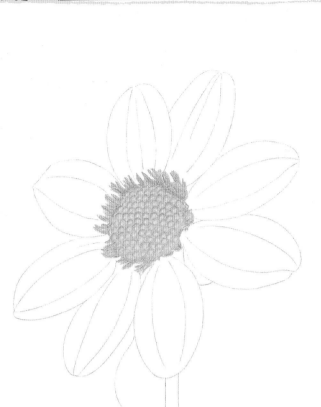

2 Paint the Center

Burnish the darkest values of the center with French Grey 30%, 10% and Goldenrod. Lightly burnish with Spanish Orange and Sunburst Yellow, leaving a small white area of white at the center of each "bump." Holding a cotton swab perpendicular to the paper, dab each "bump" with Bestine.

3 Paint the Petals' First Layer

Burnish shadows cast by the yellow tendrils in the center with Terra Cotta. Draw the "grooves" in the petals with Scarlet Lake at the back end of the petals and Terracotta (Polychromos) and Burnt Ochre (Polychromos), at the middle and front end. Layer less pigment next to the groove lines to show depth.

Starting at the back of the petal and moving toward the tip, layer Scarlet Lake, Poppy Red, Pale Vermilion, Orange, Yellowed Orange, Spanish Orange and Deco Yellow using linear strokes following the length of the petal. Leave a light line by using less pigment next to each groove.

4 Burnish the Petals with Color
Lightly burnish the petals with Deco Orange.

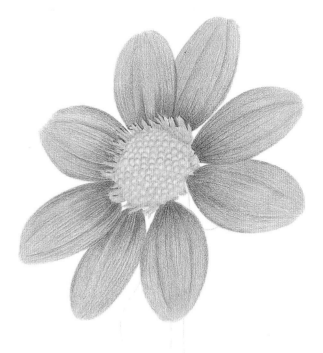

5 Burnish the Second Layer
Repeat steps 3 and 4, continuing to cover the paper surface.

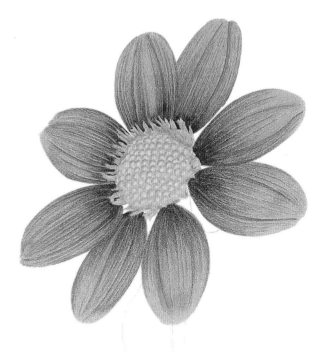

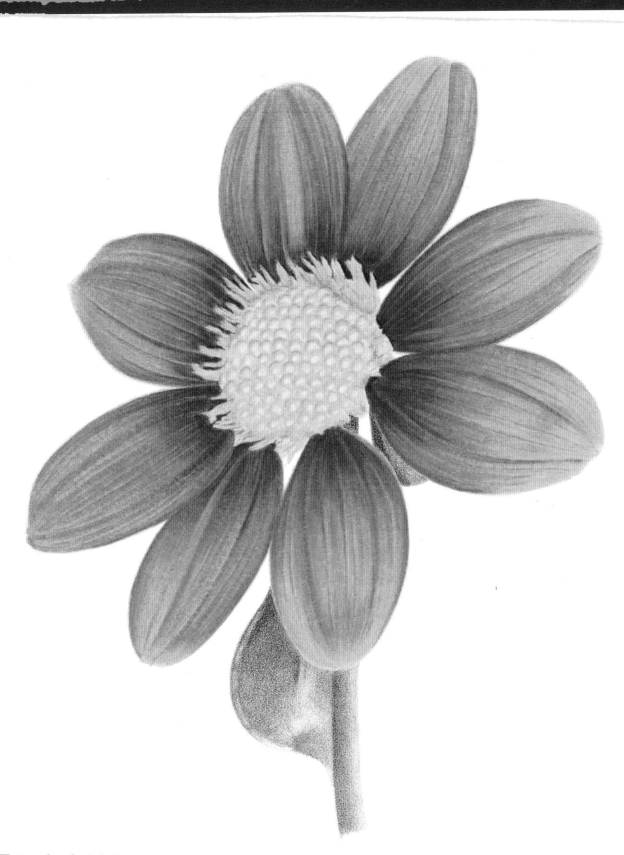

Complete the Painting

Burnish the petals with colorless blender until the paper surface is completely covered. Layer the leaves and stem with Warm Grey 70% in the darkest areas only, then Dark Green, Olive Green and Limepeel.

Layer & Burnish on Colored Paper

While blue paper seemed an obvious choice for this blue-tinted waterfall, the particular shade of blue was not. This mid-value paper allows for more control over the range of values than would have been possible with a darker blue.

MATERIALS

PAPER
Canson Mi-Teintes
Royal Blue

COLORED PENCILS
(Colors are Sanford Prismacolor.)
Apple Green • Cool Grey 90%, 30%, 20% and 10% • Indigo Blue • Light Umber • Non-Photo Blue • Sepia • True Blue • White

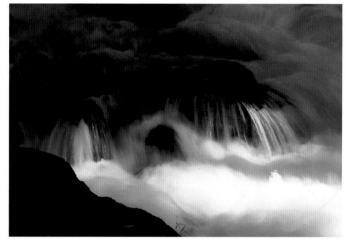
Reference Photo

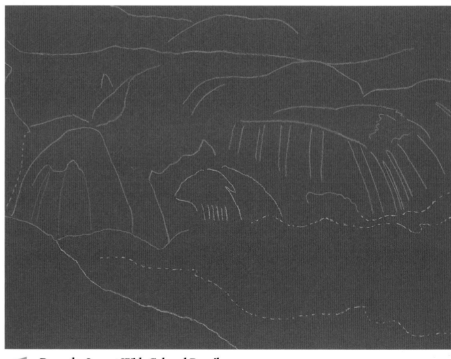

Draw the Layout With Colored Pencil
Prepare the layout as explained on page 28.

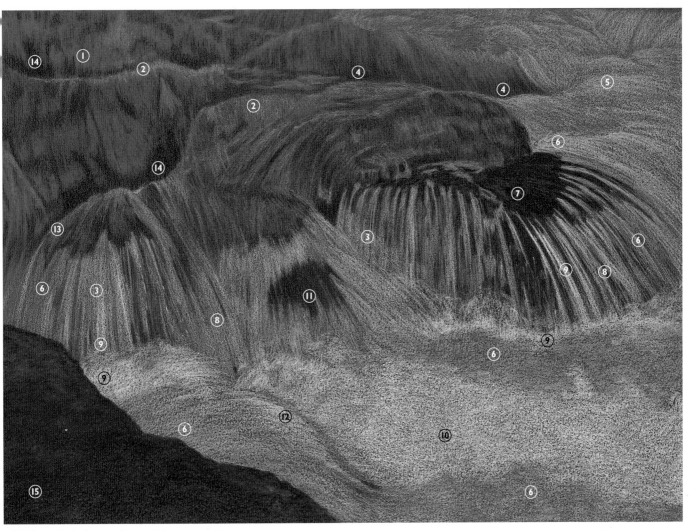

2 Apply Colors and Burnish

Apply the colors below where they are indicated. Then burnish the foreground left rock with Cool Grey 90%, Sepia, Light Umber and Apple Green.

1 True Blue

2 Cool Grey 30%, True Blue

3 Cool Grey 20%

4 Indigo Blue

5 Cool Grey 30%, 20%, True Blue

6 Cool Grey 20%, True Blue

7 Sepia, Light Umber

8 Cool Grey 10%, Non-Photo Blue

9 White

10 Cool Grey 10%, White

11 Cool Grey 90%, 30%

12 Cool Grey 10%

13 Indigo Blue, Cool Grey 30%, True Blue

14 Cool Grey 90%, Indigo Blue

15 Cool Grey 90%, Sepia, Light Umber and Apple Green

Burnish as You Go With Colorless Blender to Paint Metal

In this demonstration you'll burnish with colorless blender as you layer the color one area at a time, instead of layering the entire subject at once. Shiny metal is a natural for colored pencil but many artists are perplexed as to how to paint it successfully. The solution is simple: Just pay attention to the reflection's subtleties and reproduce them. And even though you're painting a copper pitcher, you won't use any metallic colored pencils. In general, metallic colors are undesirable and unnecessary to create the look of metal.

MATERIALS

PAPER
3-ply bristol vellum

BRUSHES
No. 2 round

COLORED PENCILS
(Colors are Sanford Prismacolor, except where noted.)
Burnt Ochre (Polychromos) • Copenhagen Blue • Dark Umber • Deco Orange • Deco Peach • French Grey 90%, 70%, 50% and 30% • Goldenrod • Jasmine • Limepeel • Mineral Orange • Olive Green • Periwinkle • Sepia • Terracotta (Polychromos) • Violet Blue • White

OTHER
Bestine • Colorless blender • No. 16 X-acto blade

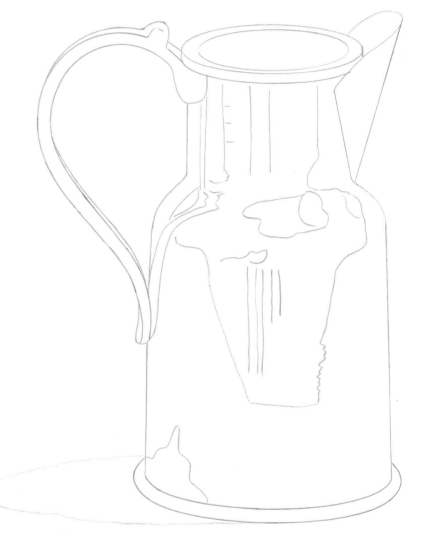

Draw the Layout With Colored Pencil
Prepare the layout as explained on page 28.

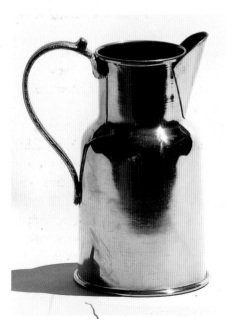

Reference Photo

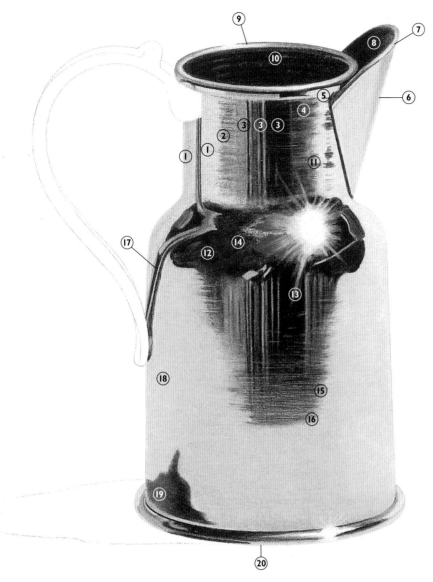

Deco Orange and White. Leave the highlight white.

10 Layer the pitcher's inside with Sepia and Dark Umber. Burnish that with Burnt Ochre (Polychromos), the dark bands with Sepia, then all with colorless blender.

11 Burnish with Deco Orange.

12 Layer the body's large dark reflection with Sepia, Dark Umber, Olive Green, Limepeel, Blue Violet, Copenhagen Blue, Periwinkle, Terracotta (Polychromos) and Deco Peach. Leave the highlight white. Burnish each area separately with colorless blender.

13 Burnish the light rays coming from the highlight with White.

14 Using circular strokes, reburnish the green areas with Olive Green, Limepeel, Sepia and Dark Umber.

15 Lightly burnish the lower part of the dark reflection with Deco Orange.

16 Lightly scrape the lower part and sides of the dark reflection with a no. 16 X-Acto blade.

17 Layer the handle's reflection with Dark Umber, Mineral Orange, Burnt Ochre (Polychromos), Terracotta (Polychromos) and Deco Orange. Burnish with colorless blender.

18 Layer the rest of the body with Terracotta (Polychromos), Deco Orange and White. Burnish with a colorless blender.

19 Layer the reflection in the lower left corner with Dark Umber, Burnt Ochre (Polychromos), Terracotta (Polychromos) and Deco Orange. Burnish with colorless blender.

20 Layer bottom edge with Sepia, Dark Umber, Burnt Ochre (Polychromos), Terracotta (Polychromos), Deco Orange and White. Leave the highlight area free of color. Burnish with colorless blender.

2 Apply the First Layers of Color

1 Working left to right with horizontal linear strokes, layer the neck with Burnt Ochre (Polychromos), Terracotta (Polychromos), Deco Orange and White.

2 Lightly apply Dark Umber.

3 Using vertical linear strokes, layer Mineral Orange, Burnt Ochre (Polychromos), Dark Umber and Sepia.

4 Layer Dark Umber, Deco Orange and White with horizontal linear strokes.

5 Layer Deco Orange, White, Dark Umber and Terracotta (Polychromos) with horizontal linear strokes. Burnish with colorless blender.

6 Layer the outside of the spout with Terracotta (Polychromos) (darker value on right outside edge only), Deco Orange and White. Burnish with colorless blender.

7 Layer the spout's edge with Sepia, Dark Umber, Mineral Orange, Burnt Ochre (Polychromos), Deco Orange and White. Leave a small area free of color.

8 Layer the inside of the spout with Sepia and Dark Umber. Burnish the edge and inside spout with colorless blender.

9 Layer the rim with Sepia, Dark Umber, Mineral Orange, Burnt Ochre (Polychromos), Terracotta (Polychromos),

3 Underpaint the Brass Handle

Layer handle with Jasmine, leaving the highlight areas free of color. Add Bestine with a no. 2 round.

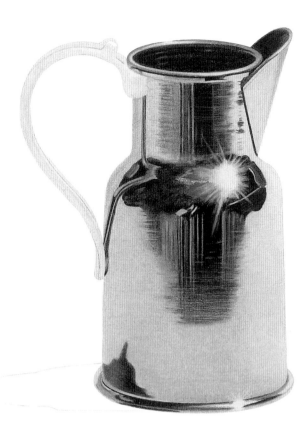

4 Paint the Brass Handle

Liberally layer Sepia and Dark Umber to the handle, leaving the highlight area free of color. Lightly layer Jasmine and Goldenrod. Lightly burnish with the colorless blender.

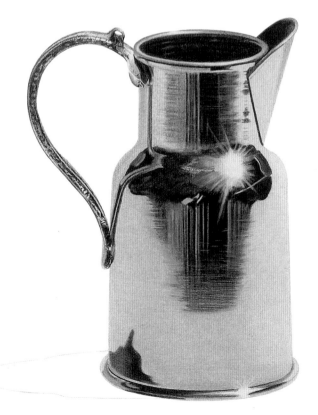

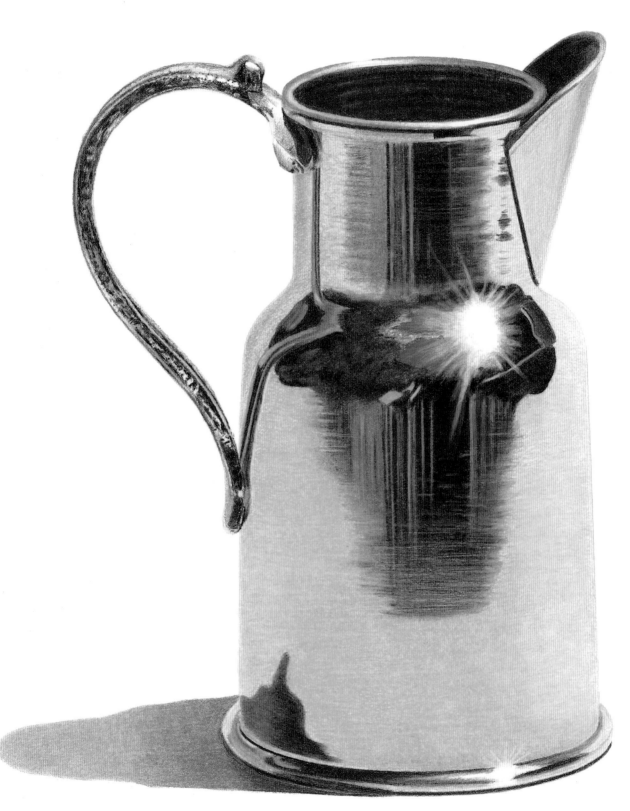

5 **Paint the Shadow to Finish**
Layer French Grey 90%, 70%, 50%, 30% and Deco Peach.
Re-layer French Grey 70%, 50% and 30% until most of the paper
surface is covered. Burnish with a colorless blender.

Paint With Solvents

A s I mentioned before, the process of painting with colored pencil requires more time than with other mediums. Using solvents can, however, speed up the process, although the results are not exactly the same. With solvents you can create soft surfaces, smooth gradations and subtle textures such as clouds, skies, water and foliage. You can apply colors all at once and mixed together or one at a time, adding solvent to each layer.

TREES AT SUNSET
Colored pencil on 3-ply bristol vellum
8½" x 11" (22cm x 28cm)

Solvent Practice

As you learned on page 16, different solvents produce different results. Be careful when using solvents with strong colors such as red, dark blue and violet. These colors can become impossible to work with because their intensity doesn't allow you to blend them or add other colors.

Smudge the pencil layers first with a cotton swab or cotton balls (depending on the area's size), then add the solvent. You can go back with your kneaded or imbibed eraser to partially erase or lighten areas painted with solvent as well as adding additional colors on top.

MATERIALS

PAPER
3-ply bristol vellum

COLORED PENCILS
(Colors are Sanford Prismacolor.)
Canary Yellow • Non-Photo Blue • Poppy Red

OTHER
Bestine • Cotton balls • Cotton swabs

APPLY SOLVENT TO LAYERED COLORS ALL AT ONCE

1 Layer Colors
Using a circular stroke, layer Poppy Red and Canary Yellow.

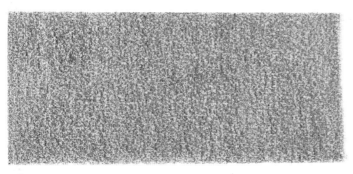

2 Smudge the Pencil Layers
Smudge the layers with a dry cotton swab.

3 Apply Solvent
Dip a clean cotton swab into a small amount of solvent. Add solvent to the layers.

APPLY SOLVENT TO ONE LAYER AT A TIME

1 Apply a Single Color and Smudge
Using a circular stroke and light pressure, layer Non-Photo Blue and smudge with a dry cotton swab.

2 Apply Solvent
Apply Bestine with a cotton swab just as you did when you layered the colors all at once.

3 Apply the Next Layer of Color
Layer Canary Yellow. Use the same light pressure and stroke as you did to apply your beginning layers.

4 Apply Solvent to New Layers
Apply Bestine with a cotton swab. When you apply Bestine to each layer of color, the colors will not mix together.

QUICK TIPS

SOLVENT SAFETY

- Pour solvent into containers smaller than baby food jars with screw-on caps.
- When applying solvent, open container, dip applicator in solvent, cover the container with the cap (it's not necessary to screw it back on) and apply. This prevents unnecessary exposure to fumes.
- Do not reuse the applicator once you have dipped it in solvent and used it on your painting.
- Use in well-ventilated areas.
- Do not smoke when using solvents.
- If solvent comes in contact with your skin, wash with soap and water.

Use Solvent to Paint Clouds

To maximize the fleecy softness of clouds of any kind, blend their pigments with a cotton swab or cotton balls before applying solvent. Beautiful clouds can be created using layering, burnishing and solvent techniques.

MATERIALS

PAPER
3-ply bristol vellum

BRUSHES
No. 6 round

COLORED PENCILS
(Colors are Sanford Prismacolor.)
Cloud Blue • Cool Grey 70%, 50%, 30%, 20% and 10% • Slate Grey

OTHER
Bestine • Cotton swabs or cotton balls • Kneaded or imbibed eraser

1 Draw the Layout With Colored Pencil and Layer the Sky
Prepare the layout as explained on page 28. Layer the sky with Slate Grey and Cloud Blue, using soft, linear, horizontal strokes. Apply less color in lighter areas. Gently rub painted areas with a dry cotton swab or cotton ball, depending on the size of the area. Repeat the process until the color is uniform.

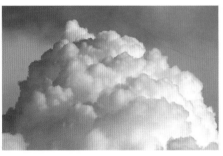

Reference Photo

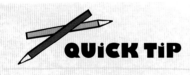

QUICK TIP

If you have sensitive skin, wear a rubber glove when using Bestine. If you get it on your fingers, wash your hands when you're finished.

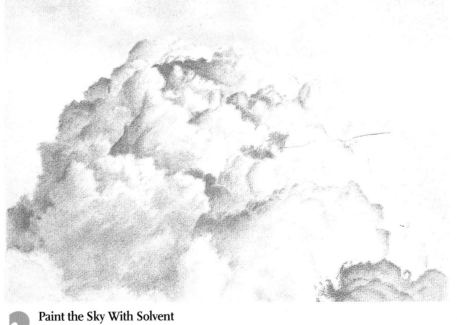

2 Paint the Sky With Solvent
Apply Bestine to the sky using cotton swabs. Replace the cotton swabs when they dry out. Lightly layer Cloud Blue to darker areas of the sky. With a kneaded or imbibed eraser, lightly erase lighter areas of the sky in selected areas. Reapply Bestine.

3 Layer the Cloud

Using small, circular strokes, layer Cool Grey 70% for the darkest areas, then apply Cool Grey 50%, 30%, 20% and 10%, darkest areas to lightest. For the lightest areas, leave the paper free of pigment.

Lightly rub the gray areas with dry cotton swabs, changing them frequently. Lightly layer Cloud Blue over gray areas only. Do not cover bare paper. Lightly rub with dry cotton swabs, changing them frequently.

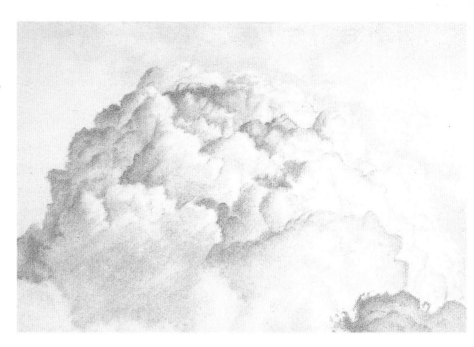

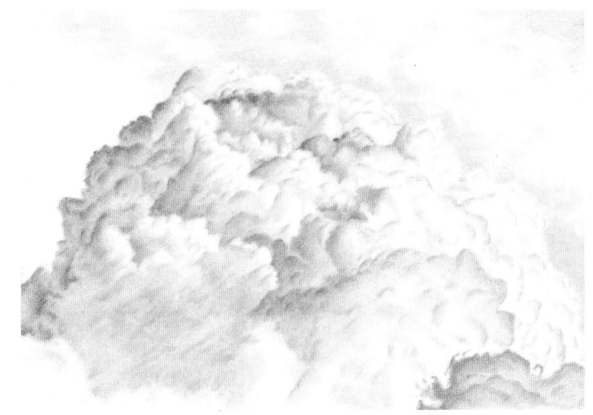

4 Blend the Cloud

Using a no. 6 round with Bestine, blend the gray layered areas of the cloud. Lightly re-layer Cool Grey 70% and 50% to the darkest areas.

With a pointed kneaded or imbibed eraser, lightly erase any highlight (bare paper) areas that may have been blended with Bestine. Lightly re-layer Cool Grey 20% and 10% to lighter areas.

Create Textures With Underpainting

The underpainting technique involves applying a light layer of muted color to a toothy paper surface, then adding solvent. Since this causes little damage to the paper's tooth, you can layer dry, darker colors on top of it to create an illusion of texture.

With watercolor pencil, underpainting produces a more uneven look than with dry colored pencil and solvent. You can create underpaintings with a combination of watercolor pencil and wax- or oil-based colored pencil. If you combine the two types of pencils though, completely and thoroughly dry the watercolor pencil underpainting before you add wax- or oil-based colored pencil and solvent on top.

MATERIALS

PAPER
3-ply bristol vellum

COLORED PENCILS
(Colors are Sanford Prismacolor.)
Cloud Blue • Cool Grey 90%

OTHER
Bestine • Cotton swabs

WORDS TO KNOW

UNDERPAINTING A preliminary coat of color or colors that serves as a base for the rest of a painting.

1 Apply an Even Layer of Colored Pencil
Using circular strokes, layer Cloud Blue.

2 Add Solvent
Apply Bestine with a cotton swab.

3 Add a Darker Color on Top
Using circular strokes, layer Cool Grey 90%. Vary the amount of pigment by adding additional layers without additional pencil pressure and leaving spots of the underpainting bare.

Use Underpainting to Create an Apple

Underpainting is a good idea almost any time you have a light background with a dark colored area over it. Trying to add a light background to a dark colored area will just contaminate the lighter background with the darker color. You can successfully paint apples using any colored pencil technique, but because of the heavily red variegation (darker color) over the pale yellow surface (light background), underpainting works best.

MATERIALS

PAPER
3-ply bristol vellum

BRUSHES
No. 2 round • No. 6 round

COLORED PENCILS
(Colors are Sanford Prismacolor, except where noted.)
Brown Ochre (Polychromos) • Cloud Blue • Cool Grey 70%, 50%, 30% and 20% • Crimson Lake • Dark Brown • Dark Sepia (Polychromos) • Dark Umber • Jasmine • Light Umber • Limepeel • Poppy Red • Scarlet Lake • Tuscan Red • Yellow Ochre

OTHER
Bestine • Cotton swabs

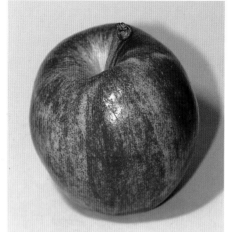

Reference Photo

1 Draw the Layout with Colored Pencil
Prepare the layout as explained on page 28.

2 Underpaint the Apple
Layer the entire apple with Jasmine. Use curved strokes that follow the apple's longitudinal contours. Leave the highlight area white.

3 Add Solvent and Underpaint the Shadow
Apply Bestine using cotton swabs with the same curved strokes, following the apple's contour. Replace cotton swabs as they dry out. Layer the shadow with Cloud Blue. Apply Bestine to the shadow area with a cotton swab.

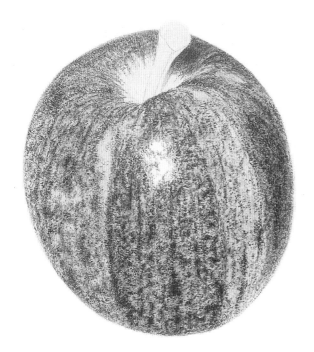

4 Paint the Apple

Lay out the stem with Light Umber. Lay out the stem's shadow with Cool Grey 50%.

Layer the stem's shadow with Cool Grey 50%, then apply Bestine with a no. 2 round.

Paint the apple's texture with Poppy Red by lightly layering with small circular strokes, stippling and adding short linear strokes that follow the longitudinal contours. Color one section at a time.

Dab with Bestine using a no. 6 round. Re-layer with Poppy Red and reapply Bestine as necessary. If some areas become too dense with color, tap them lightly with a kneaded eraser.

Add Crimson Lake and Scarlet Lake to the darker areas. Dab with Bestine and a no. 6 round. Layer Tuscan Red and Crimson Lake to the stem's shadow where it falls on the red areas only. Dab with Bestine and a no. 2 round.

5 Paint the Apple's Center, Stem and Shadow

After each of the following layers, apply Bestine with a no. 2 round to blend the colors. Very lightly apply to the apple's center first Limepeel, then Brown Ochre (Polychromos), Yellow Ochre and finally a light layer of Scarlet Lake.

Apply Bestine with a no. 2 round between each of the layers to the stem's shadow as well. Begin in the shadow center with Light Umber followed by a light layer of Limepeel.

Layer the stem itself with Dark Sepia (Polychromos), Dark Umber, Dark Brown, Brown Ochre (Polychromos) and Limepeel. Apply Bestine with a no. 2 round at the end.

Layer the shadow with Cool Grey 70%, 50%, 30% and 20%. Lightly blend with a dry cotton swab. Very lightly layer Poppy Red to the shadow's lower quarter. Lightly blend with a dry cotton swab.

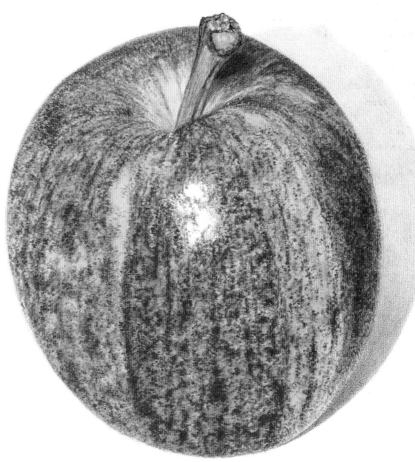

Underpaint with Solvent to Create Weathered Wood and Rust

Two distinct textures of weathered wood and rust are explored in this demonstration using underpainting with Bestine and dry colored pencil. The difference in appearance between the two is created by the strokes, a circular stroke for the rusty doorknob and a linear stroke for the wood. It is important to note that constant pencil sharpening is necessary to layer the lines that simulate weathered wood texture. Oil-based colored pencils are preferred to do the line work because they are harder than wax-based pencils and so hold their points through more strokes. We'll change the rusty doorknob's color in the demonstration to avoid a painting that's too monochromatic.

MATERIALS

PAPER
3-ply bristol vellum

COLORED PENCILS
(Colors are Sanford Prismacolor, except where noted.)
Beige • Brownish Beige (Pablo) • Burnt Ochre (Polychromos) • Burnt Sienna (Polychromos) • Dark Sepia (Polychromos) • Dark Umber • Light Umber • Terracotta (Polychromos) • Terra Cotta • Tuscan Red • Van Dyck Brown (Polychromos) • Warm Grey 90%

OTHER
Bestine • Cotton swabs • Kneaded eraser

Reference Photo

1 Draw Layout with Colored Pencil
Prepare the layout as explained on page 28.

2 Underpaint Weathered Door and Rusty Knob
Layer the cast shadow on the doorknob plate with Burnt Ochre (Polychromos), using circular strokes. In the same manner, apply Bestine with a cotton swab.

Lightly layer the cast shadow on the wood with Van Dyck Brown (Polychromos), using vertical linear strokes. Apply Bestine with a cotton swab with the same stroke. Repeat this process with Beige, then apply Bestine over the entire wood area.

Layer the doorknob and plate with Terracotta (Polychromos), using circular strokes. Leave the keyhole free of color. Apply Bestine with a cotton swab and circular strokes. Erase the doorknob's upper left highlight area with a kneaded eraser.

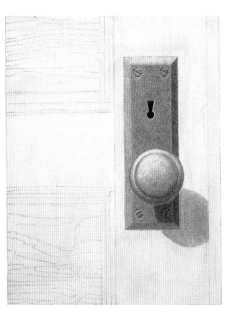

3 Paint the Rusty Doorknob

Layer the plate's left vertical edge lightly with Terracotta (Polychromos), Terra Cotta, then Dark Umber. Leave the top horizontal edge of the plate as is.

Lightly layer the plate's bottom horizontal edge and the shadow on the plate's face with Dark Umber. Layer the plate's face, left vertical and bottom horizontal edge with Terracotta (Polychromos), Terra Cotta, Light Umber and Tuscan Red.

Layer the darkest areas of the doorknob with Dark Umber, then apply Terracotta (Polychromos), Terra Cotta, Light Umber and Tuscan Red to the rest, leaving the upper left quadrant untouched. Layer the screws with Dark Umber (cast shadows only), Terracotta (Polychromos), Terra Cotta, Light Umber and Tuscan Red, leaving upper left edges free of additional color.

Burnish the keyhole with Warm Grey 90% and Dark Umber. Leave right edge free of color for the highlight.

4 Paint the Weathered Wood

Use linear strokes for this step.

Vertical Section

Heavily layer Polychromos colors Dark Sepia and Van Dyck Brown to the cracks and darkest impressions. Leave the underpainted surface to the right of the long vertical crack for the highlight. Use the same colors for the shadow cast by the doorknob.

Vary the stroke distance to layer Polychromos colors Dark Sepia, Van Dyck Brown, Burnt Sienna and Burnt Ochre and Brownish Beige (Pablo). Layer strokes closer together and leave the underpainted surface free of added color for the indentations.

Horizontal Sections

Heavily layer the crack in the upper section with Polychromos Dark Sepia. Layer Polychromos colors Van Dyck Brown and Burnt Sienna to the upper section. Leave the underpainted surfaces free of color. Layer Polychromos colors Dark Sepia (darkest values only), Van Dyck Brown and Burnt Sienna to the center, leaving the underpainted surface free of color for lighter areas. Place random light layers of Polychromos colors Van Dyck Brown and Burnt Sienna to white areas of the center section. Erase the underpainting for the lightest area of the lower section.

Heavily layer the crack in the lower section with Polychromos Dark Sepia, leaving the underpainted surface free of color underneath the crack for the highlight. Then layer Polychromos colors Van Dyck Brown and Burnt Sienna. Lightly layer the lightest areas with Brownish Beige (Pablo).

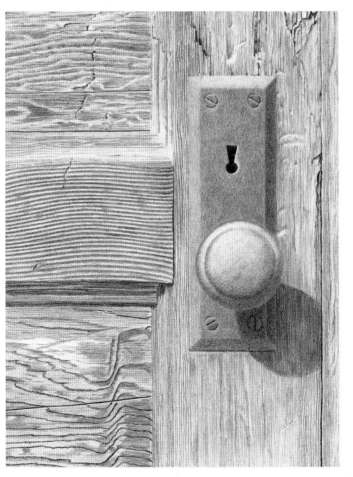

Use Solvent and Burnishing to Paint Trees at Sunset

Underpainting with solvent is a perfect way to capture the subtleties of a sunset. Paint the lighter, yellow areas first to avoid contaminating them with the darker values. Then, gradually apply several layers of color and solvent to each area to get consistent coverage. If you apply heavy layers of colors, you won't be able to control them when it's time to add solvent, creating a huge mess.

MATERIALS

PAPER
3-ply bristol vellum

COLORED PENCILS
(Colors are Sanford Prismacolor, except where noted.)
Black Cherry • Cream • Dahlia Purple • Deco Orange • Deco Yellow • French Grey 20% • Jasmine • Mineral Orange • Periwinkle • Pumpkin Orange • Warm Grey 90% • Warm Grey VI (Polychromos)

OTHER
Bestine or Turpenoid • Cotton swabs

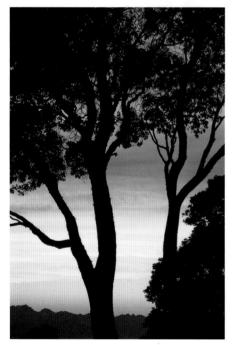

Reference Photo

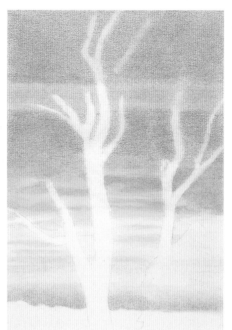

1 Draw the Layout with Colored Pencil and Paint the Sky

Prepare the layout as explained on page 28.

Use a horizontal linear stroke for the sky except where noted. After each layer of color, apply Bestine with a cotton swab. Layer the lightest part of the yellow sky with Cream, graduating to Deco Yellow. Then layer French Grey 20% to the yellow area.

Using a circular stroke, layer the lower sky with Jasmine. Then use the circular stroke to layer the lower sky with Mineral Orange.

Layer the middle orange sky area with Mineral Orange and Deco Orange. Layer the upper orange sky area with Deco Orange. Layer the lower purple area with Deco Orange, Dahlia Purple and Periwinkle. Layer the upper purple sky area with Dahlia Purple and Periwinkle. Remember to apply Bestine with a cotton swab after each layer.

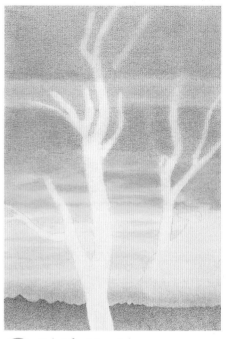

2 Paint the Mountains

Using a circular stroke, layer the mountains with Black Cherry and Pumpkin Orange, graduating to a lighter value at the bottom. Don't apply Bestine to the mountains.

QUICK TIP

More than one application of color and solvent is usually necessary for consistent color. Use Turpenoid or mineral spirits, instead of Bestine, with cotton balls for larger areas.

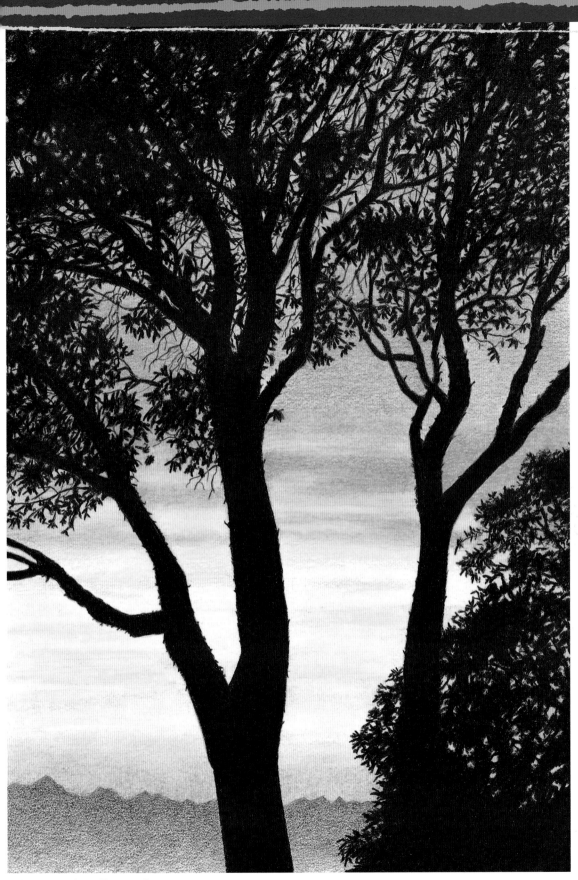

3 Paint the Silhouetted Trees

Using heavy linear strokes, burnish the trees' silhouettes with Warm Grey 90%. Burnish the smaller details with Warm Grey VI (Polychromos).

CHAPTER FIVE

Watercolor Pencils & Combining Techniques

Watercolor pencils (also known as water-soluble colored pencils) have been available for many years, but few artists realize how versatile they are. You can use them exactly like watercolor paints. You can apply them dry or wet with the pencil and even wet with a brush, yet they always retain the same characteristics as wax- or oil-based colored pencils.

Once you become familiar with watercolor pencil basics, you'll begin to combine everything you've learned so far. You'll combine watercolor pencils with dry colored pencils, underpainting with layering, even burnishing alongside solvent techniques. All the versatility of colored pencils comes together in the following pages. Let's get started!

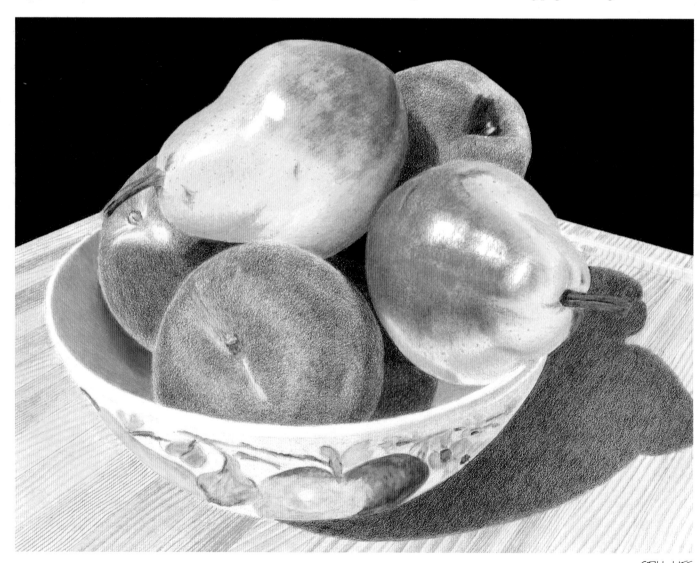

STILL LIFE
Colored pencil and watercolor pencil on cold-pressed watercolor paper
11" × 8½" (28cm × 22cm)

Practice the Traditional Watercolor Pencil Technique

Traditional watercolor pencil technique is similar to the technique you used for dry colored pencils. Create layouts with watercolor pencil the same as you would with wax- or oil-based colored pencils too; just use watercolor pencil for the final lines. When you add water, these lines will disappear.

MATERIALS

PAPER
300-lb. (640gsm) cold-pressed watercolor paper

BRUSHES
No. 6 round

WATERCOLOR PENCILS
(Colors are Faber-Castell Albrecht Dürer.)
Apple Green • Sap Green

1 Layer the Watercolor Pencils

Layer the left side of the cube with Apple Green; the right side with Sap Green and the top with Sap Green and Apple Green. Layer all of the color to a particular area. Apply the colors in the same sequence as you would wax- or oil-based colored pencils, darkest values first, working up to the lightest value on top.

2 Add Water to Blend the Colors

Using horizontal strokes, apply water with a medium-dry, no. 6 round to each face separately. Allow each face to dry before doing the next. Start at the lightest area and work toward the darkest. Don't apply too much water. Too much may cause the colors to run together and produce uneven coverage. Remove water from the brush by blotting it into a paper towel before painting.

If there are thin spots after the painting is dry, lightly layer more color on top. In smaller areas, it may not even be necessary to add water.

Paint Texture With Watercolor Pencil

Rough watercolor paper and the traditional watercolor pencil technique enhance this red onion's wonderful texture.

MATERIALS

PAPER
Rough watercolor paper

BRUSHES
No. 4 round • No. 6 round • No. 8 round

WATERCOLOR PENCILS
(Colors are Faber-Castell Albrecht Dürer, except where noted.)
Burnt Ochre • Cold Grey V, IV and III • Cream • Dark Chrome Yellow • Dark Red • Flesh Pink (Derwent) • Middle Cadmium Red • White (Prismacolor)

OTHER
Cotton balls

1 **Draw the Layout With Watercolor Pencil**
Prepare the layout as explained on page 28.

Reference Photo

2 **Begin the Underpainting**
Layer the top portion of the onion with Flesh Pink (Derwent) and Cream. Layer the onion using curved strokes following its longitudinal contours with Dark Chrome Yellow and Burnt Ochre, leaving the paper free of color in the highlight area. Remove excess pigment and smooth by gently rubbing with dry cotton balls.

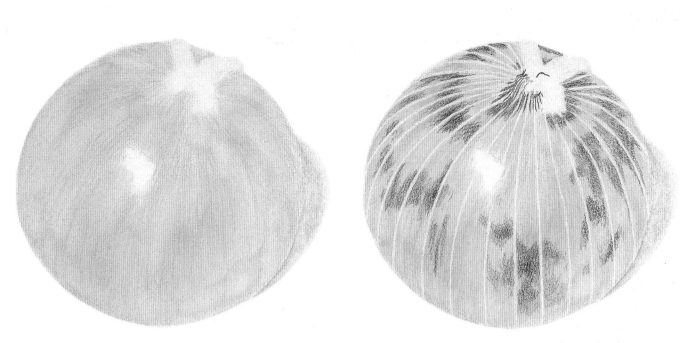

3 Add Water and the Shadow

Apply water using a nearly dry no. 6 round stiff bristle brush, with strokes following the onion's contours.

Layer the shadow using Cold Grey III. Apply water to the shadow with a medium-dry no. 6 round.

4 Draw the Section Lines and Paint the Dark Values

Draw the longitudinal section lines with White (Prismacolor), using heavy pressure. Apply Dark Red.

5 Add Water to the Dark Red Values

Apply water to the dark red areas with a nearly dry no. 6 round.

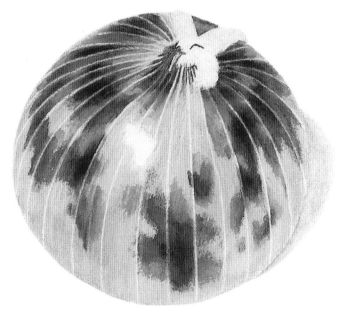

6 Layer the Onion Skin
Layer Middle Cadmium Red and Burnt Ochre, leaving the onion's lower area free of color. Drag color into the lower area with a dry cotton swab. Lightly re-layer Middle Cadmium Red to the areas where color was removed.

7 Add Water to the Entire Onion
Apply water with a medium-dry no. 8 round.

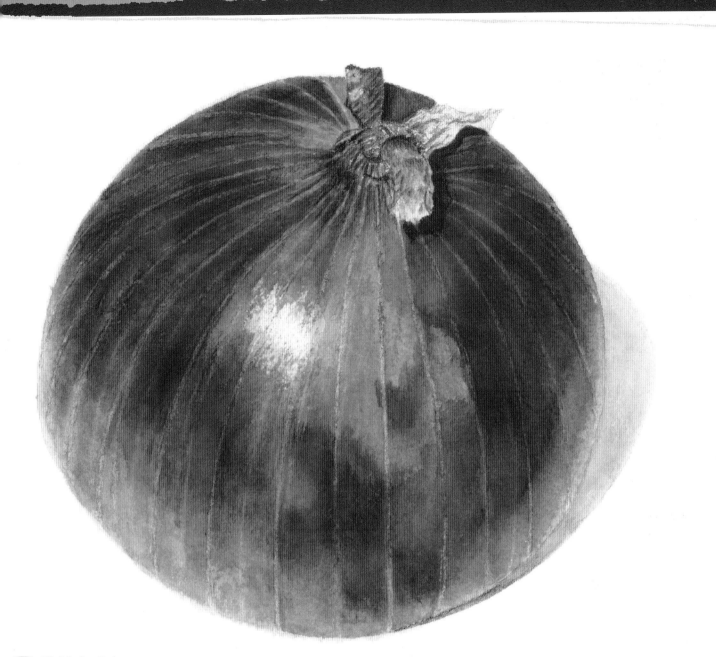

8 Finish the Onion

Draw and layer the top of the onion with Dark Red, Middle Cadmium Red and Burnt Ochre, leaving some underpainted areas free of additional color. Apply water with a very dry no. 4 round. Layer the shadow with Cold Grey V, IV and III. Apply water with a dry no. 4 round.

Create Textures With a Watercolor Pencil Underpainting

Watercolor pencils are excellent for underpainting with wax- or oil-based colored pencils layered on top. This combination allows you to create textures with a more uneven look, such as rocks, water and foliage. Circular strokes on top of a watercolor pencil underpainting simulate grainy surfaces such as sand and gravel. Linear strokes can create surfaces like wood, water and cloth. In this exercise, you'll create the look of rust.

MATERIALS

PAPER
300-lb. (640gsm) cold-pressed watercolor paper

BRUSHES
No. 6 round

COLORED PENCILS
(Colors are Sanford Prismacolor:)
Dark Umber • Light Umber • Pumpkin Orange • Terra Cotta • Tuscan Red

WATERCOLOR PENCILS
(Faber-Castell Albrecht Dürer)
Terracotta

QUICK TIP

DIFFERENT TEXTURES REQUIRE DIFFERENT STROKES

Use circular strokes to simulate sand, rocks or other grainy surfaces. Use linear strokes to create surfaces like wood, water and cloth. You can vary the technique by adding solvent to the layer of darker colors, burnishing over the underpainting, smudging, erasing or lightly scraping with a craft knife.

1 Apply an Uneven Layer of Watercolor Pencil
Using circular strokes and light pressure, unevenly layer Terracotta (Albrecht Dürer). Add more dry pigment in some spots and leave some paper almost bare. This will make some areas darker than others, resulting in a more realistic texture.

2 Add Water to Complete the Underpainting
Add water with a no. 6 round.

3 Apply a Darker Color on Top of the Underpainting
Using circular strokes, unevenly layer Light Umber, Terra Cotta, Pumpkin Orange, Tuscan Red and Dark Umber on top of the underpainting.

DEMONSTRATION

Paint Rocks with Watercolor Pencil Underpainting

In this demonstration, you'll begin with watercolor pencil underpaintings on rough watercolor paper, then layer wax- and oil-based colored pencil on top to describe the rocks' varied textures. Use small circular strokes to show evenly covered areas.

To depict flecks of darker material in the rocks, use *stippling* (small, random dots of color) or lay the pencil point parallel with the paper for broad strokes to apply pigment only to the high "hills" of the paper's tooth.

Begin by painting just a few rocks at a time until you get the hang of it.

MATERIALS

PAPER
Rough watercolor paper

BRUSHES
No. 6 round

COLORED PENCILS
(Colors are Sanford Prismacolor, except where noted.)
Burnt Umber (Polychromos) • Caput Mortuum (Polychromos) • Celadon Green • Cinnamon (Polychromos) • Cool Grey 90%, 70%, 50% and 30% • Cream • Dark Sepia (Polychromos) • Deco Yellow • French Grey 90%, 70%, 50%, 30%, 20% and 10% • Indian Red (Polychromos) • Jade Green • Light Umber • Limepeel • Raw Umber (Polychromos) • Sanguine (Polychromos) • Sea Green (Polychromos) • Sepia • Sienna Brown • Slate Grey • Van Dyck Brown (Polychromos) • Venetian Red (Polychromos) • Violet • Warm Grey 90%, 70%, 50%, 30%, 20% and 10% • Warm Grey IV, V and VI (Polychromos)

WATERCOLOR PENCILS
(Colors are Faber-Castell Albrecht Dürer.)
Brown Ochre • Burnt Ochre • Cinnamon • Cold Grey I • Cream • Grey Green • Ivory • Terracotta • Warm Grey I

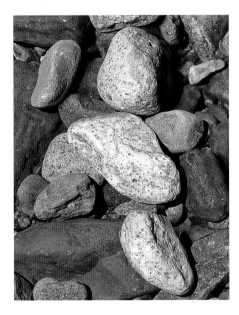

Reference Photo

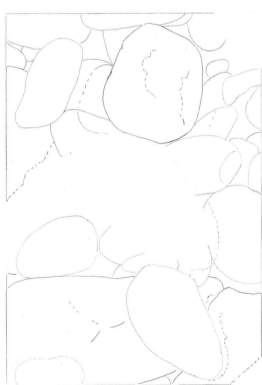

1 Draw the Layout with Watercolor Pencil

Prepare the layout as explained on page 28.

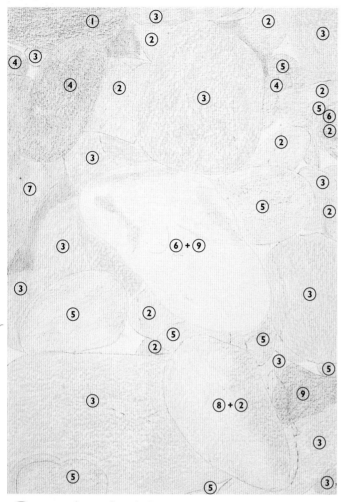

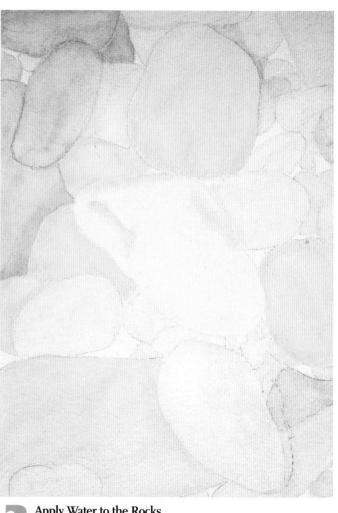

2 Layer the Underpainting

Layer the rocks with colors shown. All the colors are Albrecht Dürer.

1 Burnt Ochre
2 Warm Grey I
3 Cream
4 Grey Green
5 Cold Grey I
6 Terracotta
7 Brown Ochre
8 Ivory
9 Cinnamon

3 Apply Water to the Rocks

Apply water with a no. 6 round.

4 Layer the Rocks

Alternate between circular strokes and strokes with the pencil point parallel with the paper. Use Cold Grey VI (Polychromos) for the cast shadows and Cool Grey 90% for the rock gaps.

1 French Grey 70%, 90% and Burnt Umber (Polychromos)

2 Dark Sepia (Polychromos), Sepia, French Grey 50%, Warm Grey V (Polychromos), Caput Mortuum (Polychromos) and Raw Umber (Polychromos)

3 Caput Mortuum (Polychromos) and Burnt Umber (Polychromos)

4 Warm Grey 50% and 70%

5 French Grey 50% and 70%

6 Deco Yellow, Cream, Light Umber, Van Dyck Brown (Polychromos), Sienna Brown, Burnt Ochre (Albrecht Dürer)

7 Sienna Brown

8 Warm Grey IV and VI (Polychromos)

9 Cool Grey 50% and 90%

10 Cool Grey 50%, Jade Green and Celadon Green

11 French Grey 70% and Warm Grey V (Polychromos)

12 Warm Grey 50%, 20% and 10% and Cream

13 Cool Grey 70% and Slate Grey

14 French Grey 70% and Burnt Ochre (Albrecht Dürer)

15 Warm Grey 90% and Dark Sepia (Polychromos)

16 Light Umber, French Grey 30% and Burnt Ochre (Albrecht Dürer)

17 Cool Grey 50% and Slate Grey

18 Cool Grey 70% and 30% and Violet

19 Limepeel, Sea Green (Polychromos), Warm Grey 70%, Slate Grey and Cinnamon (Albrecht Dürer)

20 French Grey 10%, 20%, 30% and 50%, Brown Ochre (Albrecht Dürer), Burnt Ochre (Albrecht Dürer) and Sienna Brown

21 Cool Grey 50%

22 French Grey 30%

23 French Grey 70%

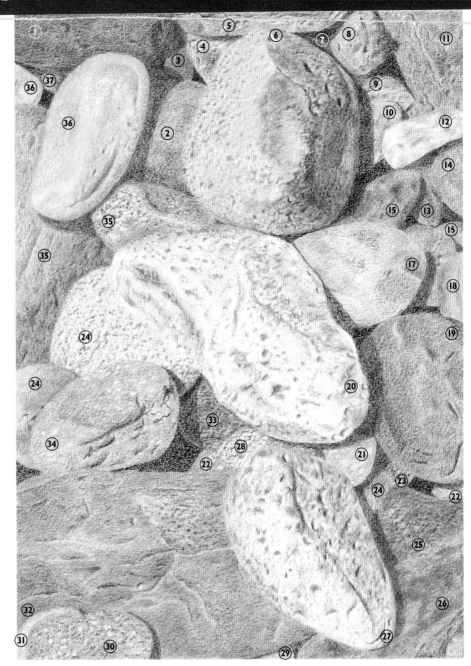

24 Light Umber and Raw Umber (Polychromos)

25 Indian Red (Polychromos), Venetian Red (Polychromos) and Cinnamon (Polychromos)

26 Brown Ochre (Albrecht Dürer), Indian Red (Polychromos), Sanguine (Polychromos), Burnt Ochre (Albrecht Dürer) and Light Umber

27 Warm Grey 90%, 70%, 50% and 30%, Brown Ochre (Albrecht Dürer) and Deco Yellow

28 Cool Grey 70%

29 Warm Grey 50%

30 Cool Grey 90% and 70%

31 Raw Umber (Polychromos)

32 Burnt Ochre (Albrecht Dürer), Raw Umber (Polychromos), Light Umber, Van Dyck Brown (Polychromos), French Grey 90%, 70% and Sienna Brown

33 Warm Grey VI (Polychromos) and French Grey 90%

34 Cool Grey 90%, 50% and 30% and Slate Grey

35 Raw Umber (Polychromos), Light Umber and French Grey 70%

36 French Grey 50% and 70%, Jade Green and Celadon Green

37 Light Umber and Burnt Umber (Polychromos)

Spray Water on Dry Pencil to Create an Autumn Leaf

There are many unique features inherent to watercolor pencils that are not available with watercolor paints. You'll learn one of them in this demonstration: spraying water on dry pencil. Your effects will vary depending on how much color or water you use.

First you'll underpaint the autumn leaf with the base color, Dark Cadmium Yellow, then spray on water with a small sprayer. You'll add the red and green layers in the same way, allowing each color to dry thoroughly before adding the next.

MATERIALS

PAPER
Rough watercolor paper

BRUSHES
No. 6 round

WATERCOLOR PENCILS
(Colors are Faber-Castell Albrecht Dürer.)

Brown Ochre • Dark Cadmium Yellow •
Emerald Green • Gold Ochre • Indian
Red • Scarlet Lake • Van Dyck Brown

OTHER
Small spray water bottle

QUICK TIP

The secret to success when using the spray method with watercolor pencils is to apply several fine mists to prevent the colors from running together.

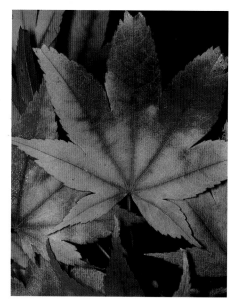

Reference Photo

1 Draw the Layout with Watercolor Pencil

Prepare the layout as explained on page 28.

2 Layer and Spray the Underpainting

Apply an even coat of Dark Cadmium Yellow.

Lay the art flat and spray the leaf with water from a small atomizer or spray bottle. Hold the bottle about four feet directly over the art and give it two or three mists, avoiding drops. Allow the art to dry. Repeat this process six or seven times, or until the pigment spreads.

3 Layer and Spray the Red

Lightly layer the yellow orange areas with Scarlet Lake. Lift and spread the red pigment with a dry cotton swab.

Re-layer with Scarlet Lake for the red areas. Just as you did in Step 2, lay the art flat and spray the leaf with water from a small atomizer or spray bottle. Allow the art to dry. Repeat the process six or seven times or until the pigment spreads.

4 Layer the Green

Lightly layer the green areas with Emerald Green. Spray the painting the same way you did in Steps 2 and 3.

5 Paint the Stem to Finish

Layer the stem with Brown Ochre. Layer Van Dyck Brown to the small area where the stem meets the leaf.

Apply water with dry no. 6 round. Allow the area to dry. Lightly layer Indian Red to upper half of stem, as shown. Again, apply water with dry no. 6 round and allow the area to dry. Layer Brown Ochre and Gold Ochre to the end of the stem. Apply water with the dry no. 6 round once more and you're finished.

Glazing with Watercolor Pencil

With this technique, you add colors one at a time to a particular area, instead of adding all the colors at once. So you apply color, wet it, allow it to dry (either naturally or using a hair dryer), then apply the next color. You repeat this sequence until the area is completed. As always with colored pencil, apply the darkest colors first, with increasingly lighter colors on top. Loosen up value gradations with water so that each value fades into the next.

This technique gives you more control and the ability to produce tighter, more detailed paintings. You need heavier paper with glazing though. The repeated addition of water may cause buckling in lighter papers.

MATERIALS

PAPER
300-lb. (640gsm) cold-pressed watercolor paper

BRUSHES
No. 4 round

WATERCOLOR PENCILS
(Colors are Faber-Castell Albrecht Dürer.)
Helio Blue-Reddish • Indanthrene Blue • Light Phthalo Blue • Phthalo Blue

1 Apply the First Layer
Apply Indanthrene Blue to the outline of the sphere with a circular stroke, just as you did on page 31.

2 Add Water
Add water with a medium-dry no. 4 round.

QUICK TiP

MAKE SURE THE COLOR IS DRY
It's very important to make sure that your previous color is dry before you add the following color when glazing. Wet paper is shiny; dry paper isn't. If you're unsure whether the color is dry or not, try holding it up to the light or to eye-level. It should easier to tell that way.

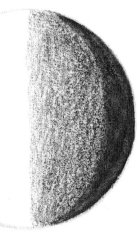

3 Overlap the Second Layer
Layer Helio Blue-Reddish, overlapping the previous color. Again, this is similar to the layering you did on page 31.

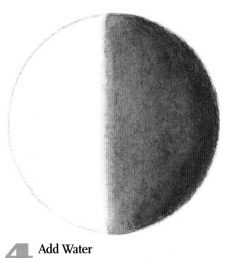

4 Add Water
Add water with a medium-dry no. 4 round.

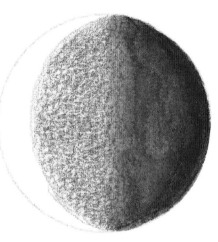

5 Add the Next Lightest Color
Layer Phthalo Blue, overlapping the previous colors. Notice you are layering colors from darkest to lightest just as you did with dry colored pencils.

6 Add Water
Add water with a medium-dry no. 4 round watercolor brush.

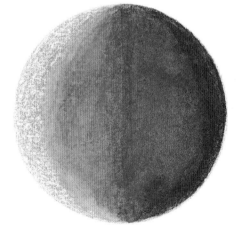

7 Add the Lightest Color
Layer Light Phthalo Blue, overlapping the previous colors.

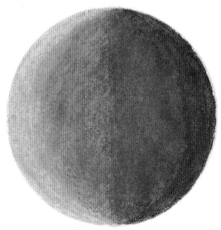

8 Add Water to Finish
Add water with a medium-dry no. 4 round.

Get the Watercolor Look With Colored Pencil Control

With watercolor pencils, you can achieve a "loose" watercolor look while maintaining the control of colored pencils. In this demonstration, you'll create the strong yet diluted red coloring of the lily's petals by adding color indirectly from a "palette" made by applying a heavy layer of color, then reapplying the color gradually in layers with a brush in order to create the petals' pastel hues. Because the Alizarin Crimson used to paint the petals is such a strong color, even the lightest layer would be too overpowering for the petals' pastel hues.

MATERIALS

PAPER
Cold-pressed
watercolor paper

BRUSHES
No. 0 round • No. 2 round • No. 4 round
• No. 6 round

WATERCOLOR PENCILS
(Colors are Faber-Castell Albrecht Dürer.)
Alizarin Crimson • Cold Grey I • Cream
• Dark Sepia • Ivory • Light Green •
Light Yellow Glaze • Sap Green •
Terracotta • Venetian Red • Warm Grey
I and II

OTHER
Cotton swabs

Draw the Layout with Watercolor Pencil
Prepare the layout as explained on page 28.

Reference Photo

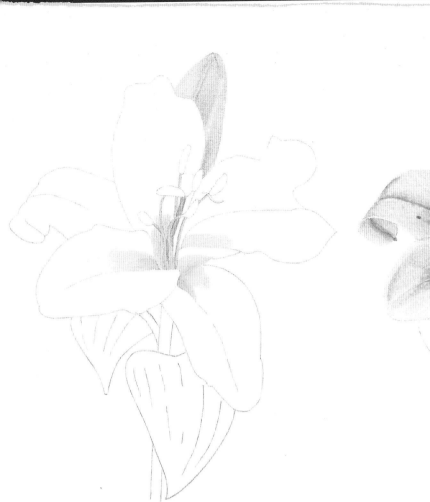

2 Paint the Flower's Weak Colors

Layer the center portions of the lily with Warm Grey I, Light Green and Light Yellow Glaze. Apply water with a medium-dry no. 2 round.

Layer the upper petal with Warm Grey II, Light Green, Sap Green, Cream and Ivory. Apply water with a medium-dry no. 6 round.

A

Apply a Heavy Layer of Alizarin Crimson

3 Paint the Petals' Strong Colors

Layer Cold Grey I to the petals' light shadow areas. Apply water with a medium-dry no. 4 round.

On a separate piece of cold-pressed watercolor paper, apply a heavy layer of Alizarin Crimson (see illustration A). Using a medium-wet no. 6 round, take a small amount of pigment from the palette and apply it to a petal, starting with the darkest area first. When the brush starts to become dry, add more water without adding pigment. Be sure the brush remains medium-wet. Before the color dries, dip a cotton swab in water, blending and lightening the color. Allow the paper to dry and then add additional layers until the desired values are achieved.

Apply the spotted texture with the point of the Alizarin Crimson pencil. Dab the spots with a medium-dry no. 4 round.

4 Paint the Leaves, Stem and Anther to Finish

On a separate sheet of watercolor paper, prepare another palette with Sap Green, just like the one in illustration A. Use the same method you used to paint the petals in step 3 to paint the leaves with Sap Green, except this time use a no. 4 round.

Lightly the layer the stem with Sap Green. Remove excess pigment with a dry cotton swab. Apply water with a dry no. 4 round and allow the area to dry completely.

Lightly layer the stem with Cream. Apply water with a dry no. 4 round. Layer the anther with Venetian Red and Terracotta. Apply water with a dry no. 2 round and allow the area to dry completely. Draw the anthers' dark lines with Dark Sepia. Apply water with a dry no. 0 round.

Underpaint With Watercolor Pencil for Bright Colors

Colorful plumage is an excellent subject for colored pencils but it is important to remember to work with weaker colors first, to avoid possible color contamination. In this demonstration, you'll complete the macaw's orange feathers, light gray feet and wooden perch to avoid possible contamination by the stronger aquamarine area. The cold-pressed paper will enhance the feather texture.

MATERIALS

PAPER
Cold-pressed
watercolor paper

BRUSHES
No. 4 round • No. 6 round

COLORED PENCILS
(Colors are Sanford Prismacolor, except where noted.)
Blue Green (Polychromos) • Burnt Ochre (Polychromos) • Cold Grey VI, V, IV, III, II and I (Polychromos) • Cool Grey 70%, 50% and 30% • Light Umber • Marine Green • Olive Green • Orange • Peacock Blue • Sap Green (Polychromos) • Spanish Orange • Spring Green • Turquoise (Polychromos) • Warm Grey V, II and I (Polychromos) • White • Yellowed Orange

WATERCOLOR PENCILS
Cold Grey III and II (Albrecht Dürer) • Dark Cadmium Yellow (Albrecht Dürer) • Raw Sienna (Derwent) • Sap Green (Albrecht Dürer) • Turquoise (Albrecht Dürer)

OTHER
Cotton balls

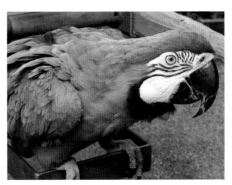

Reference Photo

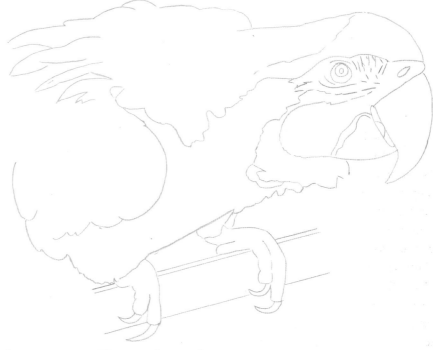

Draw Layout with Watercolor Pencil
Prepare the layout as explained on page 28.

2 Underpaint the Feet, Perch and Yellow Plumage

Layer the feet with Cold Grey II (Albrecht Dürer). Apply water with a medium-dry, no. 4 round. Layer the perch with Raw Sienna (Derwent). Apply water with a medium-dry no. 4 round.

Layer the yellow-orange feathers with Dark Cadmium Yellow (Albrecht Dürer). Apply water with a medium-dry no. 6 round.

3 Paint the Feet, Perch and Yellow Plumage; Underpaint the Aquamarine and Green Plumage

Layer the perch cast shadows with Light Umber and Burnt Ochre (Polychromos). Using a circular stroke, layer the feet with Cool Grey 70%, 50% and 30%. Using short, linear strokes, layer the orange plumage with Burnt Ochre (Polychromos), Orange, Yellow Orange and Spanish Orange.

For the turquoise and green plumage, lightly layer Sap Green (Albrecht Dürer). Lighten the pigment with a cotton ball. Apply water with a medium-dry no. 4 round, then allow the area to dry completely.

Lightly layer Turquoise (Albrecht Dürer). Lighten pigment with a cotton ball. Apply water with a medium-dry no. 4 round. Allow the area to dry again.

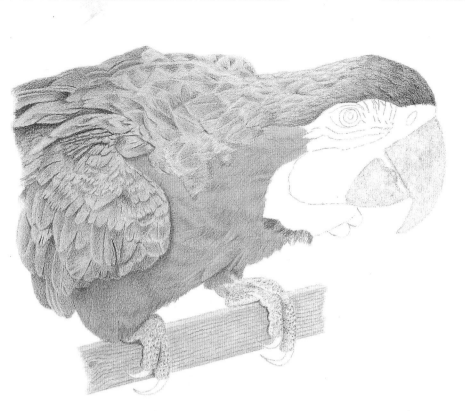

4 Paint the Turquoise and Green Plumage; Underpaint the Beak

Using short, linear strokes, layer the turquoise plumage with Peacock Blue (darkest values only), Blue Green (Polychromos) and Turquoise (Polychromos), leaving some of the underpainting free of pigment for the lightest values.

Using short, linear strokes, layer the green plumage with Marine Green, Olive Green (darkest values only) and Sap Green (Polychromos), leaving some of the underpainting free of pigment for the lightest values.

Layer the beak with Cold Grey III (Albrecht Dürer). Apply water with a medium-dry no. 6 round.

5 Finish the Macaw

Layer the white feathers on the Macaw's face with Cold Grey III, II, I (Polychromos). Layer the nostril with Cold Grey V (Polychromos).

Burnish the iris of the eye with Warm Grey II, I (Polychromos), then the pupil with Warm Grey V (Polychromos). Lightly layer the cornea with Spring Green and burnish with White. Draw the dark eyelid with Cold Grey V.

Using a linear stroke, burnish the black feathers with Cold Grey VI and V (Polychromos) and the dark markings with Cold Grey V. Using a long linear stroke, burnish the beak with Cold Grey VI, V, IV and III. Burnish the tongue with Cold Grey IV, III and the mouth with Cold Grey VI. Burnish the talons with Cold Grey VI and V.

Combine Colored and Watercolor Pencils for a Solid Background

Colored pencil and watercolor pencils combine to quickly cover large, dark, solid-colored areas such as backgrounds. This involves painting with watercolor pencil, then burnishing with wax- or oil-based colored pencils. It is not necessary to gradually add the dry pencil over the watercolor pencil underpainting, especially when using one color. The idea with this technique is to cover large areas as quickly as possible.

MATERIALS

PAPER
300-lb. (640gsm)
cold-pressed
watercolor paper

BRUSHES
No. 6 round

COLORED PENCILS
(Sanford Prismacolor)
Tuscan Red

WATERCOLOR PENCILS
(Faber-Castell Albrecht Dürer)
Dark Red

OTHER
Colorless blender

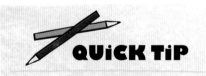

QUICK TIP

WATERCOLOR PENCIL FIRST
Always complete the watercolor pencil portion of a painting first, as it is very difficult to paint water over wax or oil.

1 Apply Watercolor Pencil
Evenly layer Dark Red.

2 Add Water
Add water with a no. 6 round.

3 Apply Wax- or Oil-Based Colored Pencil
Layer Tuscan Red until paper surface is completely covered.

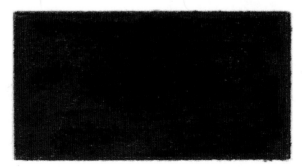

4 Burnish With Colorless Blender
Using heavy pressure, burnish with a colorless blender.

Combine Techniques to Paint a Realistic Flower

It's time to learn to combine several techniques. The pansy's petals lend themselves to using two underpaintings: a yellow underpainting done with watercolor pencil and a red underpainting done with wax-based colored pencil and solvent. You'll need to apply the red in two separate layers to keep it workable. If you apply it too heavily, it will be difficult to control.

The dark variegations drawn in the layout stage show through both underpaintings because of colored pencil's translucency. These variegations are re-drawn after the yellow underpainting and again in the petal's final step. Because the reference photo did not show much detail in the leaves and stems, they were left layered to de-emphasize them.

MATERIALS

PAPER
Cold-pressed watercolor paper

BRUSHES
No. 1 round • No. 6 round • No. 12 round

COLORED PENCILS
(Colors are Sanford Prismacolor, except where noted.)
Apple Green • Celadon Green • Crimson Lake • Crimson Red (Verithin) • Deco Yellow • French Grey 70%, 50%, 20% and 10% • Goldenrod • Limepeel • Olive Green • Poppy Red • Scarlet Lake • Sienna Brown • True Green • Tuscan Red (Verithin) • White

WATERCOLOR PENCILS
Dark Cadmium Yellow (Albrecht Dürer)

OTHER
Bestine • Cotton swabs

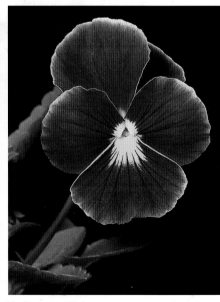

Reference Photo

1 Draw the Layout With Colored Pencil
Prepare the layout as explained on page 28. Make the layout lines for the variegations heavier than normal so they will remain visible through the underpaintings.

2 Apply the First Underpainting
Layer the petals with Dark Cadmium Yellow (Albrecht Dürer). Apply water using a medium-dry no. 12 round.

3 Apply the First Red Layer
Draw the dark variegations with a Tuscan Red Verithin pencil and the lighter variegations with a Crimson Red Verithin.

Layer Scarlet Lake over the yellow underpainted petals. Leave more showing at the petals' edges and leave a thin line free of pigment next to the variegations on the uppermost petal.

4 Paint the First Red Layer with Bestine
Apply Bestine using long strokes from the inside to the outside edge of the red areas of the petals with a no. 6 round. Use a no. 1 round for the tighter areas. Reapply Bestine with a cotton swab.

5 Apply the Second Red Layer
Lightly redraw variegations with Tuscan Red (Verithin) and the lighter variegations with Crimson Red (Verithin). Layer the darkest shadows with Crimson Lake. Layer the outside edges with White and re-layer the petals with Scarlet Lake.

Lightly blend with a dry cotton swab, dragging pigment to the petals' outside edges. Re-layer Scarlet Lake to the more intensely colored areas. Burnish with a colorless blender, dragging some pigment to the edge of the petal.

Burnish with Scarlet Lake and Poppy Red in more intensely colored areas. Burnish the darker variegations with Tuscan Red (Verithin) and the lighter variegations with Scarlet Lake. Clean up the edges with Crimson Red (Verithin).

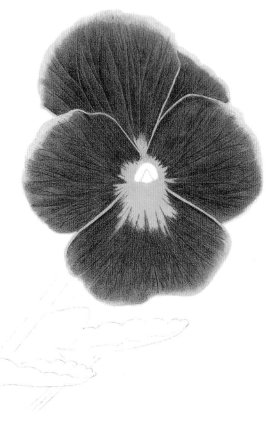

6 Paint the Center and the Foliage

Layer the center white area with Deco Yellow and burnish with White. Lightly burnish the cast shadows on the yellow center with Goldenrod. Layer the entire center with French Grey 20%, Apple Green and Deco Yellow then burnish with French Grey 10%. Then, add Scarlet Lake and Sienna Brown.

Layer the stem with Olive Green and Apple Green. Layer the leaves' cast shadows with French Grey 70%. Layer the leaves with Olive Green, French Grey 50%, 20%, 10%, Celadon Green, True Green and Limepeel.

Combine Techniques to Paint a Still Life

Colored pencil allows you to use a wide variety of techniques side-by-side in a painting and provides you with a wide range of creative possibilities. You'll create five different textures using five different techniques in this demonstration. You'll use underpainting to render a wood cutting board, watercolor pencil to convey a hand-painted look, burnishing with white to create the waxy look of pears, layering to show the fuzzy texture of a peach and burnishing with a colorless blender for a black background.

MATERIALS

PAPER
3-ply bristol vellum

BRUSHES
No. 2 round • No. 4 round

COLORED PENCILS
(Colors are Sanford Prismacolor, except where noted.)
Apple Green • Beige • Burnt Umber (Polychromos) • Chartreuse • Cloud Blue • Cool Grey 50%, 30% and 10% • Cream • Crimson Lake • Crimson Red • Dark Sepia (Polychromos) • Dark Umber • Deco Yellow • French Grey 50% and 30% • Jasmine • Light Umber • Limepeel • Orange • Pale Vermilion • Raw Umber (Polychromos) • Spring Green • Tuscan Red • Warm Grey 90%, 50%, 20% and 10% • Warm Grey VI (Polychromos) • White • Yellow Chartreuse

WATERCOLOR PENCILS
Cold Grey II (Albrecht Dürer) • Deep Cobalt (Albrecht Dürer) • Gold Ochre (Albrecht Dürer) • Indian Red (Albrecht Dürer) • Peacock Blue (Albrecht Dürer) • Raw Sienna (Derwent) • Sap Green (Albrecht Dürer) • Van Dyck Brown (Albrecht Dürer)

OTHER
Bestine • Colorless blender • Cotton swabs

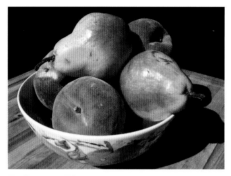

Reference Photo

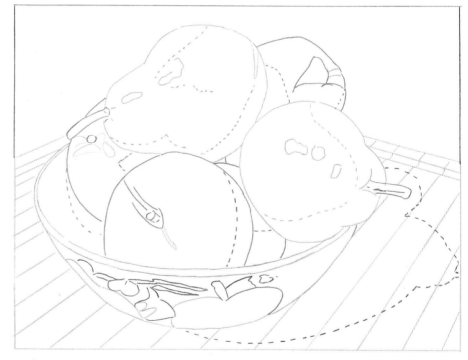

1 Draw the Layout With Colored Pencil
Prepare the layout as explained on page 28.

2 Underpaint the Cutting Board
Using linear strokes parallel with the strips, apply an even layer of Beige to the wood cutting board. Apply Bestine with a cotton swab in the same way.

3 Paint the Decorated Bowl
Layer the outer right side of the bowl with Cool Grey 50% (dark edge only), 30% and 10%. Layer left inside with Warm Grey 20%. Layer right inside with Warm Grey 50%. Apply Bestine with a cotton swab. Lightly layer the entire side with Cloud Blue. Apply Bestine with a cotton swab. Layer Gold Ochre (Albrecht Dürer) to pear, apple and petal decorations. Apply water with a dry no. 4 round. Allow the area to dry completely.

Apply Indian Red (Albrecht Dürer) to the apple and flower decorations. Apply water with a dry no. 4 round. Allow the area to dry completely. Layer Sap Green (Albrecht Dürer), Cold Grey II (Albrecht Dürer), Peacock Blue (Albrecht Dürer), Van Dyck Brown (Albrecht Dürer) and Deep Cobalt (Albrecht Dürer) to each decoration, one color at a time. With a no. 2 round, apply water to each color separately, allowing each to dry before adding the next color.

4 Paint the Pair of Pears

Layer the cast shadow on the right side of the upper pear with Light Umber and French Grey 50%. Layer the bruises with Light Umber. Layer pears with French Grey 30% (lower front of upper pear only), Limepeel, Spring Green, Chartreuse, Yellow Chartreuse, Deco Yellow, Pale Vermilion and Orange. Leave highlight areas free of color. Burnish around the highlight areas with White. Burnish with Cream. Reapply the color to the pears then burnish with a colorless blender.

Layer the stems with Dark Umber and Light Umber. Burnish those with a colorless blender.

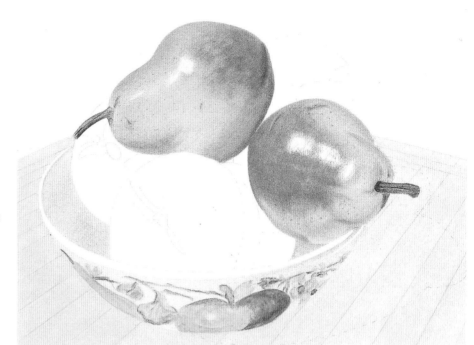

5 Paint the Peaches

Layer the peaches hidden by the darkest shadows with Warm Grey 90% and Tuscan Red. Burnish with a colorless blender.

Layer the medium dark cast shadows on the peaches with Tuscan Red and Crimson Lake. Layer the peaches with Tuscan Red, Crimson Lake, Crimson Red, Pale Vermilion and Deco Yellow, leaving the paper free of color. Layer the bare paper areas with Warm Grey 20%. Layer the stems with Light Umber, Apple Green and Jasmine. Burnish with a colorless blender.

Layer the cast shadow inside the bowl with Tuscan Red and Crimson Lake. Layer the left inside of the bowl with Tuscan Red, Crimson Red, Pale Vermilion, Warm Grey 50% and 10%.

Burnish the inside of the bowl with White. Lightly burnish the cast shadow inside the bowl with a colorless blender. Re-layer Warm Grey 50% and 10%. Burnish the inside of the bowl and the cast shadow inside the bowl with Warm Grey 10%, then a colorless blender. Burnish the small area of the inside bowl on the right with Warm Grey 50%.

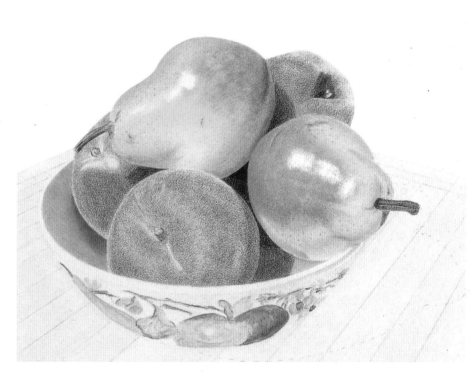

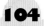

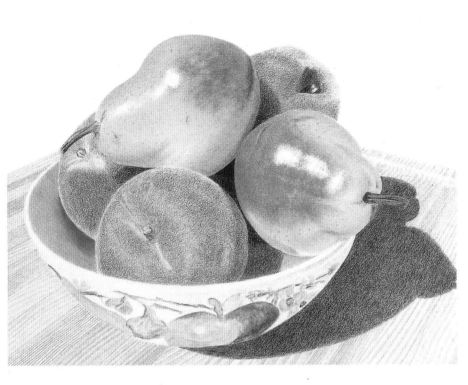

6 Paint the Cutting Board

Layer the wood grain with Burnt Umber (Polychromos), Raw Umber (Polychromos) and Raw Sienna (Derwent) in alternate strips. Very lightly draw the cracks between the wood strips with Dark Sepia (Polychromos).

Layer Dark Sepia (Polychromos) for the cast shadow on the cutting board, using a circular stroke that follows the wood grain.

7 Painting the Background

Using horizontal strokes, burnish the background with Warm Grey 90% until the paper surface is completely covered. Sharpen the edges with Warm Grey VI (Polychromos).

Try Other Watercolor Pencil Techniques

There are many ways to paint with watercolor pencils. Some allow you to paint exactly the way you would with watercolors and others can only be done with pencil. All these techniques can be combined with wax- or oil-based colored pencil and solvents. The possibilities are unlimited!

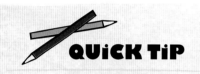

QUICK TIP

TRY THIS
Break points off and place them in a palette. Add a few drops of water and allow the points to stand for about 30 minutes. The points become the same consistency as watercolor from a tube. You can then apply the paint to a dry or wet surface using a brush.

Add Color To a Wet Surface
Wet the paper and add pigment with either a dry watercolor pencil or with the point dipped in water. You can then spread pigment with a brush if you like.

Take Pigment From the Pencil With a Brush to Add Color
Your paper can be dry or wet to do this. You can also add pigment to dry paper with a wet point and spread it with a brush.

Spray Water on Dry Color on Paper
Apply watercolor pencil as normal, then spray with water.

Sprinkle Ground Pencil on Wet Paper
Wet the paper thoroughly with a spray bottle, then sprinkle ground-up watercolor pencil lead onto the wet paper.

How to Finish Your Paintings

Because colored pencil technique involves using soft pencils on toothy papers, you'll find that edges are ragged or you have white space where you don't want any, no matter how careful you are. Don't worry though, you can clean up those edges and white spots as you paint using simple techniques and your basic tools. You can touch up your watercolor pencil paintings with wax- or oil-based colored pencils or additional layers of either dry or wet watercolor pencil.

Before

After

Cleaning Up Edges with a Verithin Pencil

Clean up your ragged edges with a Verithin or an oil-based pencil. Verithin pencils have the hardest, thinnest lead of any colored pencil and are perfectly suited for this job. Oil-based colored pencil leads are slightly harder and less brittle than wax-based colored pencils, enabling them to retain a sharp point with less breakage.

1

2

3

Touch Up Watercolor With Dry Colored Pencils

Sometimes watercolor pencil areas end up looking splotchy or uneven (1). Simply go over the uneven areas with a wax- or oil-based pencil (2) or add additional areas of watercolor pencil and then water (3) until the color becomes even.

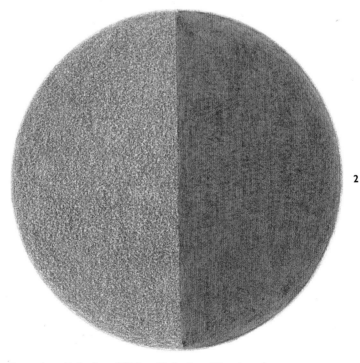

1 2

Complete Paintings With a Colorless Blender

After you burnish your paintings, you'll find that small flecks of paper (1) (actually depressions in the tooth) still remain after many layers of color. To get rid of these flecks of paper without adding more color, go over the entire area with a colorless blender (2). It will remove the flecks and add a finishing burnish to the painted area.

Conclusion

For reasons unknown to me, many art teachers discourage students from creating artwork that's detailed or tight. I was always told to work loose by my instructors. They said, "Paintings that look like photographs are not art." When I first started out, this frustrated and infuriated me because I didn't *want* my art to look loose.

After some seasoning as a professional artist, I realized that my teachers were wrong. There is no right or wrong way to create art. Art is the ultimate personal expression and not everyone is wired to express himself or herself in the same way.

I've heard the same complaints from students, some of whom have been so frustrated by the "work loose" mantra that they gave up art altogether because they thought they'd failed. However, when these artists see what can be done with colored pencil, they immediately change their point of view and give art another chance.

Like any other medium, colored pencil is not for everyone but if you've gotten this far in the book, you probably like working "tight" and creating artwork that "looks like a photograph." I hope this book has been inspiring and has opened doors for creativity that you never thought existed. The key to success in art is to enjoy it!

N-TROPY
18" x 28" (45cm x 71cm)
Colored pencil on watercolor paper

N-tropy employs every technique you've learned in this book. Inspired by a colleague's masterful pastel painting, I painted it from a twenty-year-old reference photo. It took approximately 300 hours to complete and consists of wax-based, oil-based and water-soluble colored pencils.

Glossary

Acid-Free Paper or materials with a pH of 7. If a surface contains materials with pH less than 7, the art will eventually decay.

Burnish The layering and blending of wax- or oil-based colored pencils until the entire paper surface is covered.

Cold-Pressed Paper Watercolor paper with a medium tooth that works well with most watercolor pencil techniques.

Colorless Blender Pencils consist of binder without pigment. These are used to mix colors together. They are also used as a finishing pencil for the burnishing technique.

Color Shift The hue change that happens to some watercolor pencils when water is applied and the pigment spreads out on the paper surface.

Fixative A liquid spray that binds pigment to the painting or drawing surface. When applied to a colored pencil painting, it binds the wax to the surface, preventing wax bloom.

Glazing A thin layer of color or paint over a dry layer.

Highlight The lightest value on a subject.

Hot-Pressed Paper Pressed through heated rollers, this is the smoothest watercolor paper. While it's more difficult to work with, it's excellent for detailed paintings with crisp edges.

Imbibed Eraser Available in both eraser cakes and strips for electric erasers, these are treated with erasing fluid that allows them to remove colored pencil marks with light pressure and no damage to your surface.

Kneaded Eraser Soft, rubbery erasers that may be squeezed into any shape and tend not to damage paper surfaces.

Layering The basic colored pencil technique that involves applying colors on top of each other using light pencil pressure.

Monochromatic A painting made up of different shades of the same color.

Oil-Based Colored Pencils The pigment in these pencils is bound with vegetable oil, resulting in slightly harder leads and less breakage and debris.

Opaque A medium is opaque when the color on top completely covers any pigment underneath.

Paper Tooth The degree of roughness or smoothness of a drawing surface.

Ply A paper's ply denotes its thickness. Four-ply is four sheets of one-ply paper laminated together.

Secondary Highlight A highlight that is not as white as the lightest highlight value.

Stippling Painting or drawing with small dots of ink, graphite, colored pencil or paint.

Solvent A substance that liquifies wax- and oil-based colored pencils, enabling you to cover the painting surface quickly.

Transparent A medium is transparent when it is completely see-through, as in watercolors.

Translucent The quality of being see-through, but not completely transparent.

Underpainting A preliminary coat of color or colors that serves as a base for the rest of a painting.

Value The degree of lightness or darkness of a color or tone.

Water-soluble or Watercolor Pencils Pencils just like colored pencils, except an emulsifier is added to the binder, enabling the pigment to be liquefied and used like watercolor paints.

Wax-Based Colored Pencils The most common dry colored pencil, wax-based pencils break most often and give off the most debris.

Wax Bloom A thin layer of wax that seems to "bloom" after heavy applications of pigment with wax-based colored pencils.

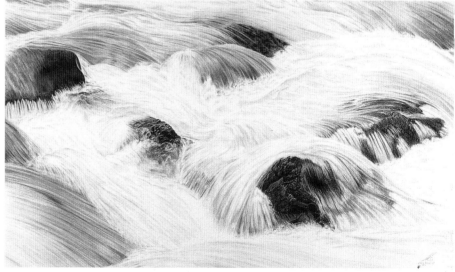

I underpainted the rocks in this painting with light colors and solvent before layering them with darker colors. I used long, linear strokes to depict the flowing water.

WATER ON THE ROCKS II
Colored pencil on 4-ply museum board
15" x 27" (38cm x 69cm)

Index

The best in Fine Art instruction and inspiration from North Light Books!

With 20 years of experience teaching drawing skills, drawing success is right around the corner with Ruth Glenn Little's easy drawing excercises. All you need is a pencil to start drawing right now!

ISBN 1-58180-595-0, 96 pages, Paperback, #33108-K

Bring your water-soluble colored pencil skills to new heights as Gary Greene teaches you to master the medium with 18 complete painting demonstrations.

ISBN 1-58180-295-1, 128 pages, Paperback, #32231-K

Gary Greene joins five other highly regarded colored pencil artists to teach you all the floral colored pencil secrets with more than 60 demonstrations.

ISBN 1-58180-172-6, 128 pages, Paperback, #31933-K

Learn the basic techniques you need to portray cats, dogs, horses, birds and more in watercolor, pencil, pen and ink, acrylic, colored pencil and watercolor pencil. The fourth book in the No Experience Required! series, you'll find success with the reliable step-by-step instruction and plentiful illustrations. Most importantly, you'll have fun creating beautiful drawings and paintings.

ISBN 1-58180-607-8, Paperback, 112 pages, #33165-K

These books and other fine North Light titles are available at your local arts & craft retailer, bookstore, online supplier or by calling 1-800-448-0915 in North America or 0870 2200220 in the United Kingdom.